STAR WARS

EPISODE I

THE PHANTOM MENACE™

The Episode 1 Titles from Del Rey Books

Star Wars: Episode 1
THE PHANTOM MENACE
by Terry Brooks

Star Wars: Episode 1
THE PHANTOM MENACE
ILLUSTRATED SCREENPLAY
by George Lucas

Star Wars: The Making of
EPISODE 1
THE PHANTOM MENACE
by Laurent Bouzereau
and Jody Duncan

The Art of Star Wars
EPISODE 1
THE PHANTOM MENACE
Written by Jonathan Bresman

STAR WARS

EPISODE I

THE PHANTOM MENACE™

ILLUSTRATED SCREENPLAY

GEORGE LUCAS

LUCAS BOOKS

DEL REY THE BALLANTINE PUBLISHING GROUP
NEW YORK

A Del Rey® Book
Published by The Ballantine Publishing Group

Copyright © 1999 by Lucasfilm Ltd. and TM.
All Rights Reserved. Used Under Authorization.

Del Rey is a registered trademark and the Del Rey colophon is a trademark of
Random House, Inc.

www.starwars.com
www.randomhouse.com/delrey/

Library of Congress Catalog Card Number: 99-90053
ISBN 0-345-43110-3

Text design by Michaelis/Carpelis Design Assoc. Inc.

Manufactured in the United States of America

First Edition: May 1999

10 9 8 7 6 5 4 3 2 1

CONTENTS

INTRODUCTION

George decided to make Episode 1 a little differently.

Most movies start with a screenplay and then are gradually translated into visual form, going through concept design, storyboard, and production art phases. Sets are built, actors are brought in, lights and cameras are set up, and a film is shot. Then the film is cut together as special effects are inserted. Throughout this assembly-line process, little pieces of the director's original vision will invariably get misinterpreted or lost along the way.

Recognizing that a lot of directing is answering an endless stream of questions from the cast and crew, George resolved to make everything clear from the beginning by creating the script and the storyboards simultaneously. And so I was charged with the task of quietly assembling a team of, as George put it, "brilliant storyboard artists." This was no easy task. When George says "brilliant," he means Joe Johnston-brilliant. The legendary Johnston had worked on the original trilogy, and, according to George, has "the best visual style—ever."

Our new team, led by Doug Chiang and Iain McCaig, did the Johnston tradition proud. Working closely with George, they constructed a shot-by-shot prototype of the film. Every space battle and lightsaber fight was sketched down to the slightest detail so that George could begin a rough edit of the film long before a single frame was shot, and so that I, of course, could begin to worry about the budget.

However, the story doesn't end with pre-production. Once we began shooting, we had to provide a cast and crew lost in a sea of bluescreen with a precise map of the movie. The storyboards served as a guide as to where actors should be stationed, which camera moves, angles, or lenses would work best, and, perhaps most important, the precise location of where each digital creation would later be inserted.

Once the film entered the post-production phase, the storyboards were used to guide Industrial Light & Magic as to where they were to place all the special effects. As George began to truly edit the film and decided to tweak the story here and there, new storyboards were generated. Whether these new shots were wholly digital or on-location pickup shots with human actors, they all went through the storyboard stage, allowing all involved to see what they were getting into.

What we were getting into was George's head, where the usual rules don't necessarily apply, and everyone has to run just to keep up. This book, which includes the finished screenplay along with some handpicked storyboards, will give you a small sense of what that's like. George put us through a strenuous creative workout (he always does). These storyboards made sure we didn't fall too far behind.

Rick McCallum, Producer

EPISODE I

THE PHANTOM MENACE™

EXT. SPACE (FX)

TITLE CARD: A long time ago in a galaxy far, far away....

A vast sea of stars serves as the backdrop for the main title, followed by a roll-up, which crawls into infinity.

EPISODE I: THE PHANTOM MENACE

Turmoil has engulfed the Galactic Republic. The taxation of trade routes to outlying star systems is in dispute.

Hoping to resolve the matter with a blockade of deadly battleships, the greedy Trade Federation has stopped all shipping to the small planet of Naboo.

While the Congress of the Republic endlessly debates this alarming chain of events, the Supreme Chancellor has secretly dispatched two Jedi Knights, the guardians of peace and justice in the galaxy, to settle the conflict....

PAN DOWN to reveal a small space cruiser heading TOWARD CAMERA at great speed. PAN with the cruiser as it heads toward the beautiful green planet of Naboo, which is surrounded by hundreds of Trade Federation battleships.

INT. REPUBLIC CRUISER—COCKPIT

In the cockpit of the cruiser, the CAPTAIN and PILOT maneuver closer to one of the battleships.

QUI-GON: *(off-screen voice)* Captain.

The CAPTAIN turns to an unseen figure sitting behind her.

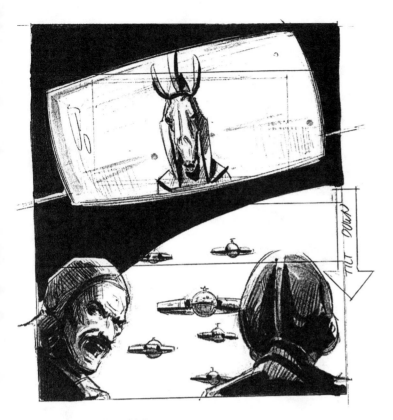

CAPTAIN: Yes, sir?

QUI-GON: *(V.O.)* Tell them we wish to board at once.

CAPTAIN: Yes, sir.

The CAPTAIN looks to her view screen, where NUTE GUNRAY, a Neimoidian trade viceroy, waits for a reply.

CAPTAIN *(Cont'd)* With all due respect for the Trade Federation, the Ambassadors for the Supreme Chancellor wish to board immediately.

NUTE: Yes, yes, of course...ahhh...as you know, our blockade is perfectly legal, and we'd be happy to receive the Ambassador... Happy to.

The screen goes black. Out the cockpit window, the sinister battleship looms ever closer.

EXT. FEDERATION BATTLESHIP—DOCKING BAY—SPACE (FX)

The small space cruiser docks in the enormous main bay of the Federation battleship.

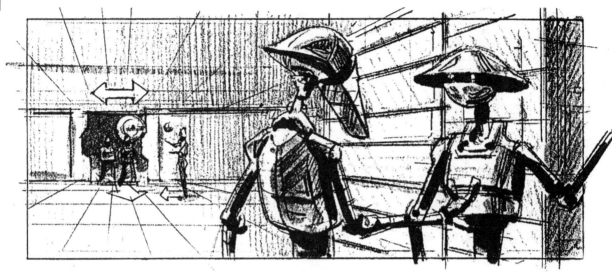

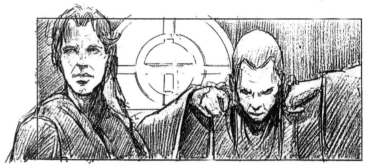

INT. FEDERATION BATTLESHIP—DOCKING BAY—SPACE

A PROTOCOL DROID, TC-14, waits at the door to the docking bay. Two WORKER DROIDS, PK-4 and EG-9 watch.

PK-4: They must be important if the Viceroy sent one of those useless protocol gearheads to greet them.

The door opens, and the Republic cruiser can be seen in the docking bay. Two darkly robed figures are greeted by TC-14.

TC-14: I'm TC-14 at your service. This way, please.

They move off down the hallway.

EG-9: A Republic cruiser! That's trouble...don't you think?
PK-4: I'm not made to think.

INT. FEDERATION BATTLESHIP—CONFERENCE ROOM

A door slides open, and the two cloaked shapes are led PAST CAMERA into the formal conference room by TC-14.

TC-14: I hope your honored sirs will be most comfortable here. My master will be with you shortly.

The droid bows before OBI-WAN KENOBI and QUI-GON JINN. He backs out the door and it closes. The JEDI lower their hoods and look out a large window at the lush green planet of Naboo. QUI-GON, sixty years old, has very long white hair in a ponytail. He is tall and striking, with blue eyes. OBI-WAN is twenty-five, with very short brown hair, pale skin, and blue eyes. Several exotic, bird-like creatures SING in a cage near the door.

OBI-WAN: I have a bad feeling about this.

QUI-GON: I don't sense anything.

OBI-WAN: It's not about the mission, Master, it's something... elsewhere...elusive...

QUI-GON: Don't center on your anxiety, Obi-Wan. Keep your concentration here and now where it belongs.

OBI-WAN: Master Yoda says I should be mindful of the future...

QUI-GON: ...but not at the expense of the moment. Be mindful of the living Force, my young Padawan.

OBI-WAN: Yes, Master... How do you think this trade viceroy will deal with the Chancellor's demands?

QUI-GON: These Federation types are cowards. The negotiations will be short.

INT. FEDERATION BATTLESHIP—BRIDGE

NUTE GUNRAY and DAULTAY DOFINE stand, stunned, before TC-14.

NUTE: *(shaken)* What?!? What did you say?

TC-14: The Ambassadors are Jedi Knights, I believe.

DOFINE: I knew it! They were sent to force a settlement, eh. Blind me, we're done for!

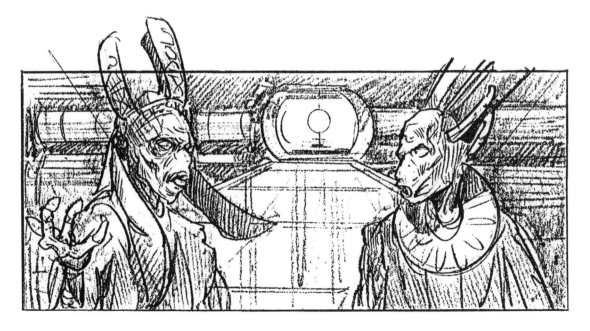

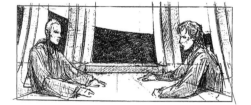

NUTE: Stay calm! I'll wager the Senate isn't aware of the Supreme Chancellor's moves here. Go. Distract them until I can contact Lord Sidious.
DOFINE: Are you brain dead? I'm not going in there with two Jedi! Send the droid.

DOFINE turns to TC-14, who lets out a squeaky sigh.

INT. FEDERATION BATTLESHIP—CONFERENCE ROOM

QUI-GON and OBI-WAN sit at the large conference table.

OBI-WAN: Is it their nature to make us wait this long?

The door to the conference room slides open, and TC-14 enters with a tray of drinks and food.

QUI-GON: No... I sense an unusual amount of fear for something as trivial as this trade dispute.

OBI-WAN takes a drink.

INT. FEDERATION BATTLESHIP—BRIDGE

NUTE, DOFINE, and RUNE HAAKO are before the hologram of DARTH SIDIOUS, a robed figure whose face is obscured by a hood.

DOFINE: ...This scheme of yours has failed, Lord Sidious. The blockade is finished! We dare not go against these Jedi.
DARTH SIDIOUS: You seem more worried about the Jedi than you are of me, Dofine. I am amused... Viceroy!

NUTE, looking very nervous, steps forward.

NUTE: Yes, My Lord.
DARTH SIDIOUS: I don't want that stunted slime in my sight again...do you understand?
NUTE: Yes, My Lord.

NUTE gives DOFINE a fierce look, and DOFINE, terrified, rushes off the bridge.

DARTH SIDIOUS: This turn of events is unfortunate. We must accelerate our plans, Viceroy. Begin landing your troops.

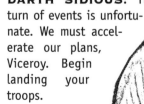

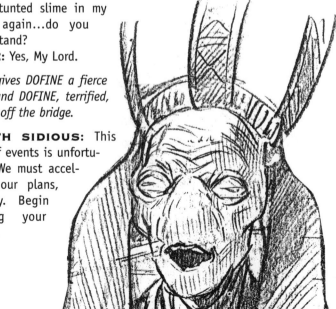

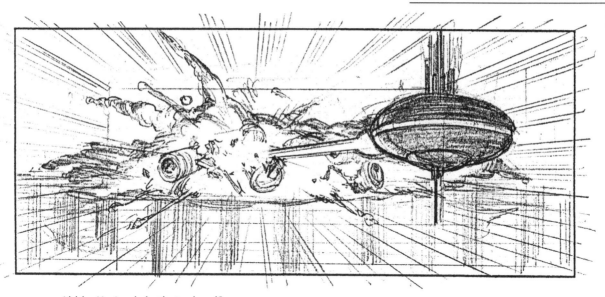

NUTE: Ahhh, My Lord, is that...legal?

DARTH SIDIOUS: I will make it legal.

NUTE: And the...Jedi??

DARTH SIDIOUS: The Chancellor should never have brought them into this. Kill them, immediately.

NUTE: Ye...yes, My Lord. As you wish.

INT. REPUBLIC CRUISER—COCKPIT—DOCKING BAY

In the cockpit of the cruiser, the CAPTAIN and PILOT look up and see a gun turret swing around and point directly at them.

PILOT: Captain!? Look!!

CAPTAIN: No! Warn...

EXT. FEDERATION BATTLESHIP—HANGAR BAY—SPACE (FX)

The battleship gun fires. The republic cruiser EXPLODES.

INT. FEDERATION BATTLESHIP—CONFERENCE ROOM

QUI-GON and OBI-WAN leap to a standing position with their laser swords drawn. TC-14 jumps back, startled, spilling the drinks on its tray.

TC-14: Ahhh... Sorry, sir. The Viceroy...

QUI-GON and OBI-WAN turn off their swords and listen intently. A faint hissing sound can be heard.

QUI-GON: Gas!

QUI-GON and OBI-WAN each take a sudden deep breath and hold it. The exotic bird-like creatures in the cage drop dead.

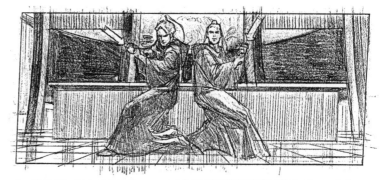

INT. FEDERATION BATTLESHIP—HALLWAY

A hologram of NUTE, surrounded by BATTLE DROIDS, appears in the conference room hallway.

NUTE: They must be dead by now. Blast what's left of them.

The hologram fades off, as a BATTLE DROID, OWO-1, cautiously opens the door. A deadly green cloud billows from the room. BATTLE DROIDS cock their weapons as a figure stumbles out of the smoke. It is TC-14, carrying the tray of drinks.

TC-14: Oh, excuse me, so sorry.

The PROTOCOL DROID passes the armed camp just as two flashing laser swords fly out of the deadly fog, cutting down several BATTLE DROIDS before they can fire.

INT. FEDERATION BATTLESHIP—BRIDGE

The bridge is a cacophony of alarms. NUTE and RUNE watch OWO-1 on the view screen.

OWO-1: ...Not sure exactly what...

OWO-1 is suddenly cut in half in mid-sentence. RUNE gives NUTE a worried look.

NUTE: What in blazes is going on down there?
RUNE: Have you ever encountered a Jedi Knight before, sir?

NUTE: Well, not exactly, but I don't...*(panicked)* Seal off the bridge...

RUNE: That won't be enough, sir.

The doors to the bridge SLAM shut.

NUTE: I want destroyer droids up here at once!!!

RUNE: We will not survive this.

INT. FEDERATION BATTLESHIP—HALLWAY—OUTSIDE BRIDGE

QUI-GON cuts several BATTLE DROIDS in half, creating a shower of sparks and metal parts. OBI-WAN raises his hand, sending several BATTLE DROIDS crashing into the wall.

QUI-GON makes his way to the bridge door and begins to cut through it.

INT. FEDERATION BATTLESHIP—BRIDGE

The CREW is very nervous as sparks start flying around the bridge door. QUI-GON and OBI-WAN are on the view screen.

NUTE: Close the blast doors!!

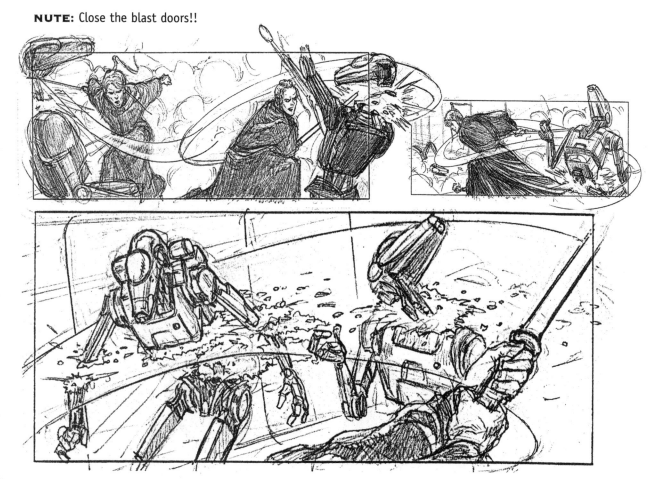

The huge, very thick blast door slams shut, followed by a second door, then a third. There is a hissing sound as the huge doors seal shut. QUI-GON stabs the door with his sword. The screens go black as a red spot appears in the center of the blast door.

RUNE: ...They're still coming through!

On the door, chunks of molten metal begin to drop away.

NUTE: Impossible!! This is impossible!!
RUNE: Where are those destroyer droids?!

INT. FEDERATION BATTLESHIP—HALLWAY—OUTSIDE BRIDGE

Ten ugly destroyer WHEEL DROIDS roll down the hallway at full speed. Just before they get to the bridge area, they stop and transform into their battle configuration. QUI-GON can't see them but senses their presence.

QUI-GON: Destroyer droids!
OBI-WAN: Offhand, I'd say this mission is past the negotiation stage.

The WHEEL DROIDS, led by P-59, rush the entry area from three hallways, blasting away with their laser guns. They stop firing and stand in a semi-circle as the smoke clears. OBI-WAN and QUI-GON are nowhere to be seen.

P-59: Switch to bio...There they are!

The Jedi materialize at the far end of the hallway and dash through a doorway that slams shut. The WHEEL DROIDS blast away at the two JEDI with their laser swords.

OBI-WAN: They have shield generators!
QUI-GON: It's a standoff! Let's go!

INT. FEDERATION BATTLESHIP—BRIDGE

NUTE and RUNE stand on the bridge, watching the view screen as the WHEEL DROIDS' POV speeds to the doorway.

RUNE: We have them on the run, sir...they're no match for destroyer droids.
TEY HOW: Sir, they've gone up the ventilation shaft.

INT. FEDERATION BATTLESHIP—MAIN BAY

QUI-GON and OBI-WAN appear at a large vent in a giant hangar bay. They are careful not to be seen. Thousands of BATTLE DROIDS are loading onto landing craft.

QUI-GON: Battle droids.
OBI-WAN: It's an invasion army.
QUI-GON: It's an odd play for the Trade Federation. We've got to

warn the Naboo and contact Chancellor Valorum. Let's split up. Stow aboard separate ships and meet down on the planet.

OBI-WAN: You were right about one thing, Master. The negotiations were short.

INT. FEDERATION BATTLESHIP—BRIDGE

TEY HOW receives a transmission.

TEY HOW: Sir, a transmission from the planet.
RUNE: It's Queen Amidala herself.
NUTE: At last we're getting results.

On the view screen, QUEEN AMIDALA appears in her throne room. Wearing her elaborate headdress and robes, she sits, surrounded by the GOVERNING COUNCIL and FOUR HANDMAIDENS, EIRTAÉ, YANÉ, RABÉ, and SACHÉ.

NUTE: *(Cont'd)* Again you come before me, Your Highness. The Federation is pleased.
AMIDALA: You will not be so pleased when you hear what I have to say, Viceroy...Your trade boycott of our planet has ended.

NUTE smirks at RUNE.

NUTE: I was not aware of such a failure.
AMIDALA: I have word that the Senate is finally voting on this blockade of yours.
NUTE: I take it you know the outcome. I wonder why they bother to vote.
AMIDALA: Enough of this pretense, Viceroy! I'm aware the Chancellor's Ambassadors are with you now, and that you have been commanded to reach a settlement.
NUTE: I know nothing about any Ambassadors...you must be mistaken.

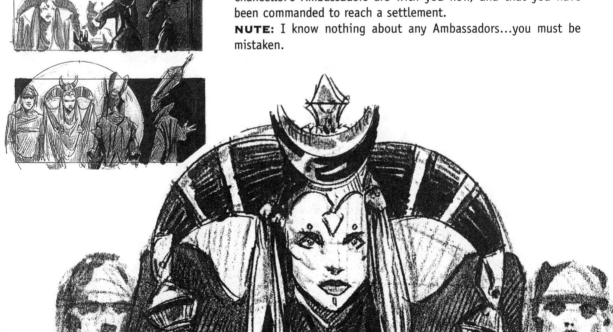

AMIDALA, surprised at his reaction, studies him carefully.

AMIDALA: Beware, Viceroy...the Federation is going too far this time.
NUTE: Your Highness, we would never do anything without the approval of the Senate. You assume too much.
AMIDALA: We will see.

The QUEEN fades off, and the view screen goes black.

RUNE: She's right, the Senate will never...
NUTE: It's too late now.
RUNE: Do you think she suspects an attack?
NUTE: I don't know, but we must move quickly to disrupt all communications down there.

INT. NABOO PALACE—THRONE ROOM

The QUEEN, EIRTAÉ, SACHÉ and her Governor, SIO BIBBLE, stand before a hologram of SENATOR PALPATINE, a thin, kindly man.

PALPATINE: ...How could that be true? I have assurances from the Chancellor...his Ambassadors did arrive. It must be the...get...negotiate...

The hologram of PALPATINE sputters and fades away.

AMIDALA: Senator Palpatine?!? *(turns to Panaka)* What's happening?

CAPTAIN PANAKA turns to his SERGEANT.

CAPT. PANAKA: Check the transmission generators....
BIBBLE: A malfunction?
CAPT. PANAKA: It could be the Federation jamming us, Your Highness.
BIBBLE: A communications disruption can only mean one thing. Invasion!
AMIDALA: Don't jump to conclusions, Governor. The Federation would not dare go that far.
CAPT. PANAKA: The Senate would revoke their trade franchise, and they'd be finished.
AMIDALA: We must continue to rely on negotiation.
BIBBLE: Negotiation? We've lost all communications!...and where are the Chancellor's Ambassadors? How can we negotiate? We must prepare to defend ourselves.
CAPT. PANAKA: This is a dangerous situation, Your Highness. Our security volunteers will be no match against a battle-hardened Federation army.
AMIDALA: I will not condone a course of action that will lead us to war.

EXT. SPACE LANDING CRAFT—TWILIGHT (FX)

Six landing craft fly in formation toward the surface of the planet Naboo.

EXT. NABOO SWAMP—SHALLOW LAKE —TWILIGHT

Three landing craft slowly descend through the cloud cover of the perpetually gray twilight side of the planet. One by one, the Federation warships land in the eerie swamp.

OBI-WAN's head emerges from the mud of a shallow lake. Far in the background, the activities of the invasion force can be seen in the mist. OBI-WAN takes several deep breaths, then disappears

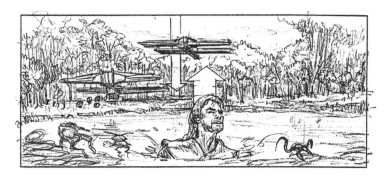

again under the muddy swamp. Troop Transports (MTT's) emerge from the landing craft.

EXT. NABOO EDGE OF SWAMP/GRASS PLAINS—TWILIGHT (FX)

The droid invasion force moves out of the swamp and onto a grassy plain. OOM-9, in his tank, looks out over the vast ARMY marching across the rolling hills. A small hologram of RUNE and NUTE stands on the tank.

RUNE: ...and there is no trace of the Jedi. They may have gotten onto one of your landing craft.
OOM-9: If they are down here, sir, we'll find them. We are moving out of the swamp and are marching on the cities. We are meeting no resistance.
NUTE: Excellent.

EXT. NABOO SWAMP—TWILIGHT

QUI-GON runs through the strange landscape, glancing back to see the monstrous troop transports emerging from the mist. Animals begin to run past him in a panic.

An odd, frog-like Gungan, JAR JAR BINKS, squats holding a clam he has retrieved from the murky swamp. The shell pops open. JAR JAR's great tongue snaps out and grabs the clam, swallowing it in one gulp.

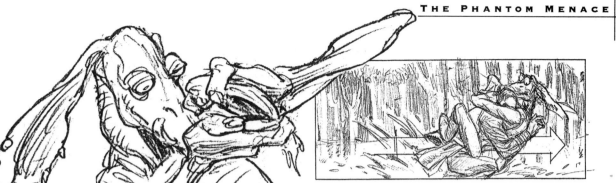

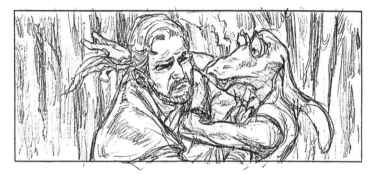

JAR JAR looks up and sees QUI-GON and the other creatures run-
ning like the wind toward him. One of the huge MTT's bears down
on the JEDI like a charging locomotive. JAR JAR stands transfixed,
still holding the clam shell in one hand.

JAR JAR: Oh, noooooooooo!

JAR JAR drops the shell and grabs onto QUI-GON as he passes. The
JEDI is caught by surprise.

JAR JAR: (Cont'd) Hey, hep me! Hep me!!
QUI-GON: Let go!

The machine is about to crush them as QUI-GON drags JAR JAR
behind him. Just as the transport is about to hit them, QUI-GON
drops, and JAR JAR goes splat into the mud with him. The transport
races overhead.
 QUI-GON and JAR JAR pull themselves out of the mud. They stand
watching the war machine disappear into the mist. JAR JAR grabs
QUI-GON and hugs him.

JAR JAR: Oyi, mooie-mooie! I luv yous!

The frog-like creature kisses the JEDI.

QUI-GON: Are you brainless? You almost got us killed!
JAR JAR: I spake.
QUI-GON: The ability to speak does not make you intelligent.
Now get outta here!

QUI-GON starts to move off, and JAR JAR follows.

JAR JAR: No...no! Mesa stay...Mesa yous humbule servaunt.
QUI-GON: That won't be necessary.
JAR JAR: Oh boot tis! Tis demunded byda guds. Tis a live debett, tis. Mesa culled JaJa Binkss.

In the distance, two STAPS burst out of the mist at high speed, chasing OBI-WAN.

QUI-GON: I have no time for this now...
JAR JAR: Say what?

The two STAPS barrel down on OBI-WAN.

JAR JAR: *(Cont'd)* Oh, nooooo! Weesa ganna...

QUI-GON throws JAR JAR into the mud.

QUI-GON: Stay down!

His head pops up.

JAR JAR: ...dieeee!

The two troops fire laser bolts at OBI-WAN. QUI-GON deflects the bolts back, and the STAPS blow up. One—two. OBI-WAN is exhausted and tries to catch his breath.

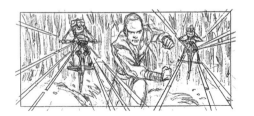

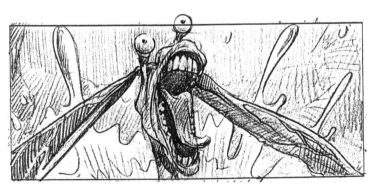

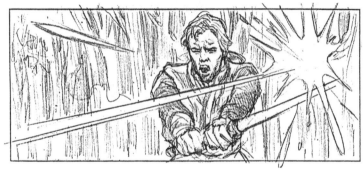

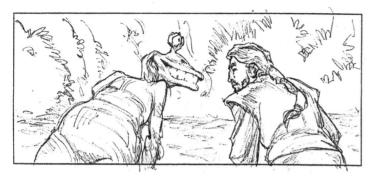

OBI-WAN: Sorry, Master, the water fried my weapon.

OBI-WAN pulls out his burnt laser sword handle. QUI-GON inspects it, as JAR JAR pulls himself out of the mud.

QUI-GON: You forgot to turn your power off again, didn't you?

OBI-WAN nods sheepishly.

QUI-GON: *(Cont'd)* It won't take long to recharge, but this is a lesson I hope you've learned, my young Padawan.
OBI-WAN: Yes, Master.
JAR JAR: Yousa sav-ed my again, hey?
OBI-WAN: What's this?
QUI-GON: A local. Let's go, before more of those droids show up.
JAR JAR: Mure?! Mure did you spake??!?

OBI-WAN and QUI-GON start to run. JAR JAR tries to keep up.

JAR JAR: *(Cont'd)* Ex-squeezee-me, but da moto grande safe place would be Otoh Gunga. Tis where I grew up... Tis safe city.

They all stop.

QUI-GON: A city! *(Jar Jar nods his head)* Can you take us there?
JAR JAR: Ahhh, will...on second taut...no, not willy.
QUI-GON: No??!
JAR JAR: Iss embarrissing, boot... My afraid my've bean banished. My forgoten der Bosses would do terrible tings to my. Terrible tings if my goen back dare.

A PULSATING SOUND is heard in the distance.

QUI-GON: You hear that?

JAR JAR shakes his head yes.

QUI-GON: *(Cont'd)* That's the sound of a thousand terrible things heading this way...
OBI-WAN: When they find us, they will crush us, grind us into little pieces, then blast us into oblivion!

JAR JAR: Oh! Yousa point is well seen. Dis way! Hurry!

JAR JAR turns and runs into the swamp.

EXT. NABOO SWAMP LAKE—TWILIGHT

QUI-GON, OBI-WAN, and JAR JAR run to a murky lake and stop as JAR JAR tries to catch his breath. The TRANSPORTS ARE HEARD in the distance.

QUI-GON: Much farther?
JAR JAR: Wesa goen underwater, okeyday?

QUI-GON and OBI-WAN pull out small capsules from their utility belts that turn into breathing masks.

JAR JAR: *(Cont'd)* My warning yous. Gungans no liken outlaunders. Don't expict a werm welcome.

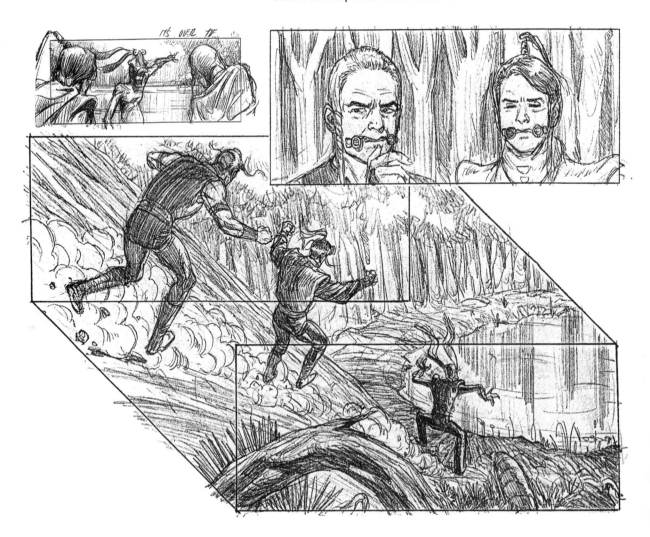

OBI-WAN: Don't worry, this has not been our day for warm welcomes.

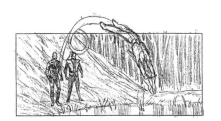

JAR JAR jumps, does a double somersault with a twist, and dives into the water.

Breath masks on, QUI-GON and OBI-WAN wade in after him.

EXT. NABOO LAKE—UNDERWATER

QUI-GON and OBI-WAN swim behind JAR JAR, who is very much at home in the water. Down they swim into the murky depths. In the distance the glow of Otoh Gunga, an underwater city made up of large bubbles, becomes more distinct.

They approach the strange, art nouveau habitat. JAR JAR swims magically through one of the bubble membranes, which seals behind him. OBI-WAN and QUI-GON follow.

INT. OTOH GUNGA—CITY SQUARE

GUNGANS in the square scatter when they see the strange JEDI. Four GUARDS armed with long electro-poles ride two-legged KAADUS into the square. The GUARDS, led by CAPTAIN TARPALS, point their lethal poles at the dripping trio.

JAR JAR: Heyo-dalee, Cap'n Tarpals, Mesa back!
CAPT. TARPALS: Noah gain, Jar Jar. Yousa goen tada Bosses. Yousa in big dudu dis time.

CAPT. TARPALS gives JAR JAR a slight zap with his power pole. JAR JAR jumps and moves off, followed by the two JEDI.

JAR JAR: How wude.

INT. OTOH GUNGA—HIGH TOWER BOARD ROOM

The Bosses' Board Room has bubble walls, with small lighted fish swimming around outside like moving stars. A long circular judge's

bench filled with GUNGAN OFFICIALS dominates the room. OBI-WAN and QUI-GON stand facing BOSS NASS, who sits on a bench higher than the others.

BOSS NASS: …Yousa cannot bees hair. Dis army of mackineeks up dare tis new weesong!

QUI-GON: That droid army is about to attack the Naboo. We must warn them.

BOSS NASS: Wesa no like da Naboo! Un dey no like uss-ens. Da Naboo tink day so smarty den uss-ens. Day tink day brains so big.

OBI-WAN: After those droids take control of the surface, they will come here and take control of you.

BOSS NASS: No, mesa no tink so. Mesa scant talkie witda Naboo, and no nutten talkie wit outlaunders. Dos mackineeks no comen here! Dey not know of uss-en.

OBI-WAN: You and the Naboo form a symbiont circle. What happens to one of you will affect the other. You must understand this.

BOSS NASS: Wesa wish no nutten in yousa tings, outlaunder, and wesa no care-n about da Naboo.

QUI-GON: *(waves his hand)* Then speed us on our way.

BOSS NASS: Wesa ganna speed yousaway.

QUI-GON: We need a transport.

BOSS NASS: Wese give yousa una bongo. Da speedest way tooda Naboo tis goen through da core. Now go.

QUI-GON: Thank you for your help. We go in peace.

QUI-GON and OBI-WAN turn to leave.

OBI-WAN: Master, what's a bongo?

QUI-GON: A transport, I hope.

The JEDI notice JAR JAR in chains to one side, waiting to hear his verdict. QUI-GON stops. JAR JAR gives him a forlorn look.

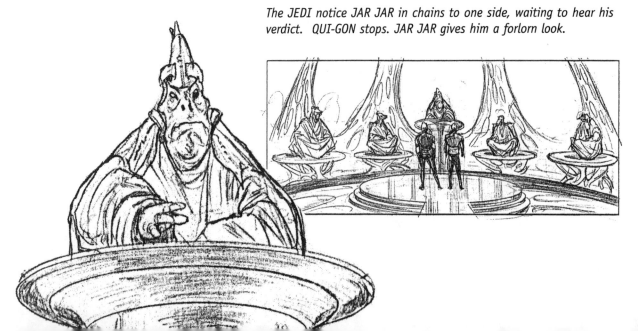

JAR JAR: Daza setten yous up. Goen through da planet core is bad bombin!!

QUI-GON: Thank you, my friend.

JAR JAR: Ahhh...any hep hair would be hot.

JAR JAR's soulful look is counterpointed by a sheepish grin.

OBI-WAN: We are short of time, Master.

QUI-GON: We'll need a navigator to get us through the planet's core. This Gungan may be of help.

QUI-GON walks back to BOSS NASS.

QUI-GON: *(Cont'd)* What is to become of Jar Jar Binks here?

BOSS NASS: Binkss brokeen the nocombackie law. Hisen to be pune-ished.

QUI-GON: He has been a great help to us. I hope the punishment will not be too severe.

BOSS NASS: Pounded unto death.

JAR JAR: *(grimacing)* Oooooh...Ouch!

OBI-WAN looks concerned. QUI-GON is thinking.

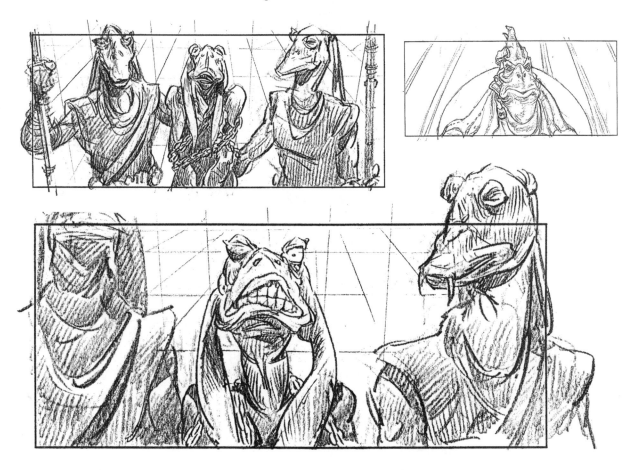

QUI-GON: We need a navigator to get us through the planet's core. I have saved Jar Jar Binks' life. He owes me what you call a "life-debt."
BOSS NASS: Binks. Yousa havena liveplay with thisen hisen?

JAR JAR nods and joins the JEDI. QUI-GON waves his hand.

QUI-GON: Your gods demand that his life belongs to me now.
BOSS NASS: Hisen live tis yos, outlaunder. Begone wit him.
JAR JAR: Count mesa outta dis! Better dead here, den deader in da core...Yee guds, whata mese sayin?!

EXT. NABOO LAKE—UNDERWATER—SUB (FX)

A strange little submarine propels itself away from Otoh Gunga, leaving the glow of the settlement in the distance.

INT. SUB COCKPIT—UNDERWATER

OBI-WAN, in the co-pilot's seat, JAR JAR guides the craft.

JAR JAR: Dis is nutsen.
OBI-WAN: Master, why do you keep dragging these pathetic life forms along with us?... Here, take over.
JAR JAR: Hey, ho? Where wesa goen??
QUI-GON: You're the navigator.
JAR JAR: Yo dreamen mesa hopen...
QUI-GON: Just relax, the Force will guide us...
JAR JAR: Ooooh, maxibig..."da Force"...Wellen, dat smells stinkowiff.

JAR JAR veers the craft to the left and turns the lights on. The coral vistas are grand, fantastic, and wondrous.

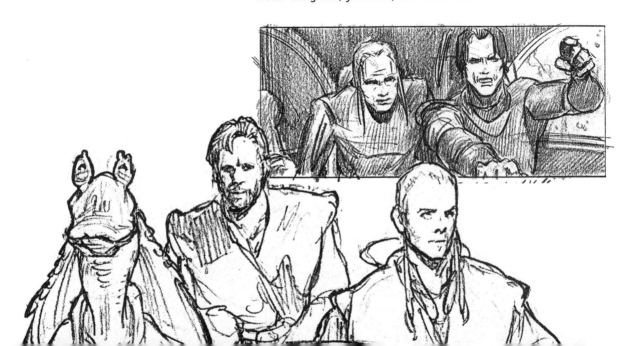

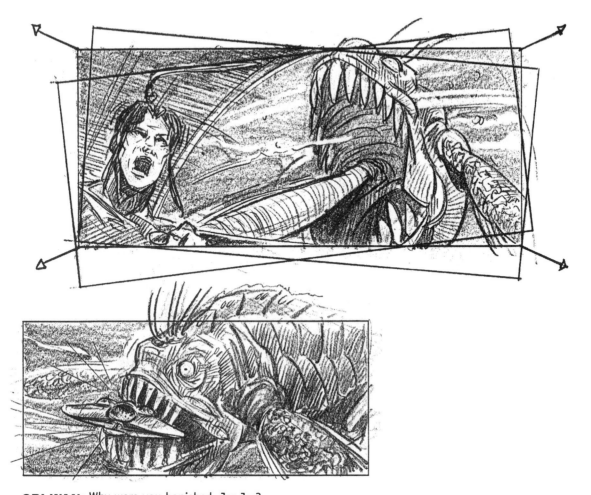

OBI-WAN: Why were you banished, Jar Jar?

JAR JAR: Tis a longo tale, buta small part wowdabe mesa...ooooh...aaaa...clumsy.

OBI-WAN: They banished you because you're clumsy?

As the little sub glides ever deeper into the planet core, a large dark shape begins to follow.

JAR JAR: Mesa cause-ed mabee one or duey lettal bitty ax-adentes...yud-say boom da gasser, un crash Der Bosses heyblib-ber...den banished.

Suddenly there is a loud CRASH, and the little craft lurches to one side. QUI-GON looks around and sees a huge, luminous OPEE SEA KILLER has hooked them with its long gooey tongue.

QUI-GON: Full speed ahead.

Instead of full ahead, JAR JAR jams the controls into reverse. The sub flies into the mouth of the creature.

JAR JAR: Ooooops.
OBI-WAN: Give me the controls.

OBI-WAN takes over the controls and the OPEE SEA KILLER instantly releases the sub from its mouth.

JAR JAR: Wesa free!

As the sub zooms away they see a larger set of jaws, munching on the hapless KILLER. The jaws belong to the incredible SANDO AQUA MONSTER. The lights on the tiny sub begin to flicker as they cruise deeper into the gloom.

QUI-GON: There's always a bigger fish.

INT. FEDERATION BATTLESHIP—BRIDGE

NUTE and RUNE stand before a hologram of DARTH SIDIOUS.

NUTE: The invasion is on schedule, My Lord.
DARTH SIDIOUS: Good. I have the Senate bogged down in procedures. By the time this incident comes up for a vote, they will have no choice but to accept your control of the system.
NUTE: The Queen has great faith the Senate will side with her.
DARTH SIDIOUS: Queen Amidala is young and naive. You will find controlling her will not be difficult. You have done well, Viceroy.
NUTE: Thank you, My Lord.

DARTH SIDIOUS fades away.

RUNE: You didn't tell him about the missing Jedi?
NUTE: No need to report that to him, until we have something to report.

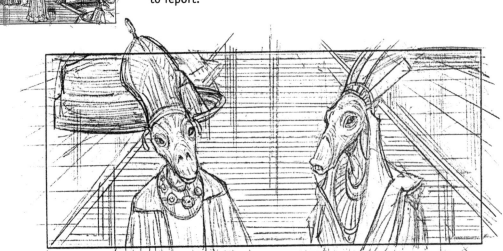

INT. SUB COCKPIT—UNDERWATER

Sparks are flying, and water is leaking into the cabin. The sound of the power drive drops.

OBI-WAN: ...we're losing power.

OBI-WAN is working with the sparking wires. JAR JAR panics.

QUI-GON: Stay calm. We're not in trouble yet.
JAR JAR: What yet? Monstairs out dare! Leak'n in here, all'n sink'n, and nooooo power! You nutsen! WHEN YOUSA TINK WESA IN TROUBLE?!!!?
OBI-WAN: Power's back.

The lights flicker on, revealing an ugly COLO CLAW FISH right in front of them.

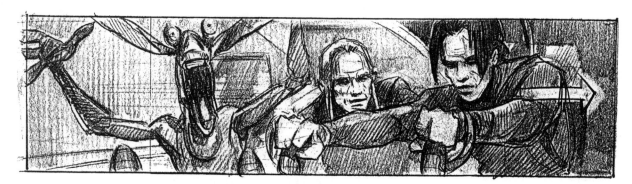

JAR JAR: Monstair's back!

The large COLO CLAW FISH is surprised and rears back. The sub turns around and speeds away.

JAR JAR: *(Cont'd)* Wesa in trouble now??
QUI-GON: Relax.

QUI-GON puts his hand on JAR JAR's shoulder. JAR JAR relaxes into a coma.

OBI-WAN: You overdid it.

The COLO CLAW FISH leaps after the fleeing sub as it shoots out of the tunnel and into the waiting jaws of the SANDO AQUA MONSTER.

OBI-WAN: *(Cont'd)* This is not good!

JAR JAR regains consciousness.

JAR JAR: Wesa dead yet?? Oie Boie!

JAR JAR's eyes bulge, and he faints again. The sub narrowly avoids the deadly teeth of the AQUA MONSTER. The COLO CLAW FISH chasing them isn't so lucky. It is munched in half by the larger predator. The little sub zips away.

QUI-GON: Head for that outcropping.

EXT. THEED—MAIN ROAD INTO THEED—DAY (FX)

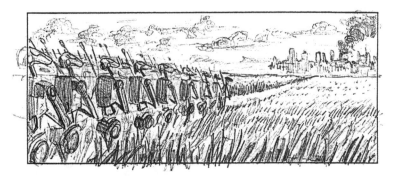

The long columns of the DROID ARMY move down the main road leading to Theed, the Naboo capital.

EXT. THEED PLAZA—DAY (FX)

As the QUEEN watches helplessly from a window in the palace, a transport carrying NUTE and RUNE lands in Theed Plaza. They exit the transport.

NUTE: Ah, victory!

INT. NABOO LAKE—UNDERWATER—SUB (FX)

The little sub continues to propel itself toward the surface, which is brightly lit.

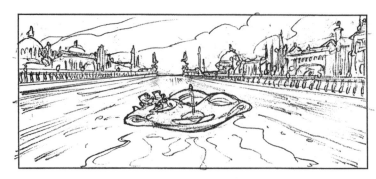

JAR JAR: Wesa dude it!

EXT. THEED—ESTUARY—DAY

Paradise. Billowing clouds frame a romantic body of water. There is a LOUD RUSH OF BUBBLES, and a small sub bobs to the surface.

The current in the estuary begins to pull the sub backward into a fast moving river. OBI-WAN switches off the two remaining bubble canopies. QUI-GON stands up to look around. JAR JAR lets out a sigh of relief.

JAR JAR: Wesa safe now.
QUI-GON: Get this thing started!
JAR JAR: Dissen berry good. Hey?
OBI-WAN: What is it?

JAR JAR looks back to where they're drifting. He sees they are headed for a huge waterfall.

JAR JAR: What!!?? Oie boie!

OBI-WAN tries to start the engine. The long props behind the sub slowly begin to rotate. OBI-WAN struggles until finally, a few feet short of the waterfall, the sub starts and is able to generate enough power to stop drifting backward in the powerful current. The sub slowly moves forward. In the background, QUI-GON takes a cable out of his belt. The engine coughs and dies. They start drifting backward again. JAR JAR panics.

JAR JAR: *(Cont'd)* Iyiiiyi, wesa die'n here, hey!

QUI-GON shoots the thin cable, and it wraps itself around a railing on the shore. The sub pulls the cable taut, and the little craft hangs precariously over the edge of the waterfall.

QUI-GON: Come on...

OBI-WAN climbs out of the sub and pulls himself along the cable. QUI-GON starts in after him.

QUI-GON: *(Cont'd)* Come on, Jar Jar.
JAR JAR: No! Too scary!
OBI-WAN: Get up here!
JAR JAR: No a mighty no!

JAR JAR looks back and sees he is hanging over the waterfall.

JAR JAR: *(Cont'd)* Oie boie...mesa comen. Mesa comen!

JAR JAR starts to climb out of the sub. OBI-WAN is on shore and helps to pull QUI-GON out of the water.

OBI-WAN: That was close.

BATTLE DROID 3B3: *(O.S.)* Drop your weapons!

The TWO JEDI turn around and see a BATTLE DROID standing in front of them. JAR JAR climbs up on shore between the JEDI.

BATTLE DROID 3B3: I said drop your weapons.

QUI-GON ignites his laser sword, and in a brief flash, the DROID is cut down by the JEDI. A stray laser bolt hits the cable and the sub breaks lose, crashing down the waterfall.

 The JEDI move on. JAR JAR reluctantly follows and looks back at the mess.

JAR JAR: Whoa!!!

EXT. THEED—PALACE—DAY

The waterfalls of Theed sparkle in the noonday sun.

INT. THEED—PALACE THRONE ROOM—DAY

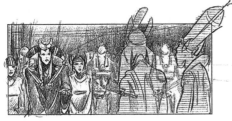

QUEEN AMIDALA, SIO BIBBLE, and FIVE OF HER HANDMAIDENS (EIRTAÉ, YANÉ, PADMÉ, RABÉ, SACHÉ) are surrounded by TWENTY DROIDS. CAPTAIN PANAKA and FOUR NABOO GUARDS are also held at gunpoint. NUTE and RUNE stand in the middle of the room.

BIBBLE: ...how will you explain this invasion to the Senate?
NUTE: The Naboo and the Federation will forge a treaty that will legitimize our occupation here. I've been assured it will be ratified by the Senate.
AMIDALA: I will not cooperate.
NUTE: Now, now, Your Highness. You are not going to like what we have in store for your people. In time, their suffering will persuade you to see our point of view. Commander. *(OOM-9 steps forward)* Process them.

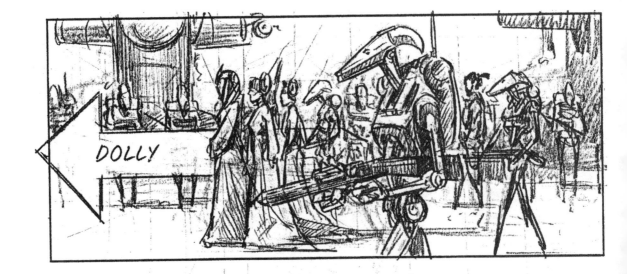

DOLLY

OOM-9: Yes, sir! *(turns to his sergeant)* Take them to Camp Four.

The SERGEANT marches the GROUP out of the throne room.

EXT. PALACE—PLAZA—DAY

QUEEN AMIDALA, PADMÉ, EIRTAÉ, YANÉ, RABÉ, SACHÉ, CAPTAIN PANAKA, SIO BIBBLE, and FOUR GUARDS are led out of the palace by ten BATTLE DROIDS. The plaza is filled with tanks and BATTLE DROIDS, which they pass on their way to the detention camp. Unbeknownst to them, QUI-GON, OBI-WAN, and JAR JAR sneak across on a walkway above the plaza and jump from a balcony to begin an attack to rescue the QUEEN.

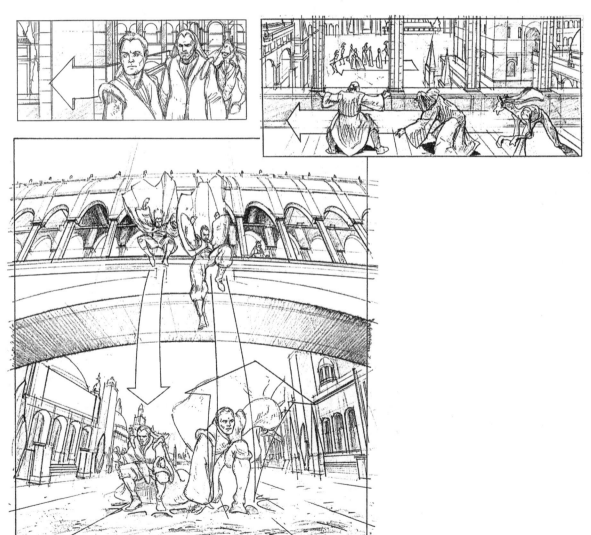

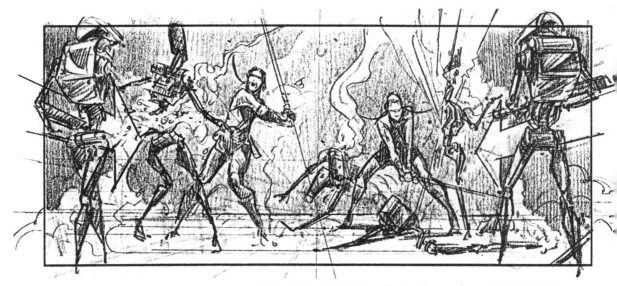

FOUR BATTLE DROIDS are instantly cut down. MORE DROIDS move forward and are also cut down by the JEDIS' flashing lightsabers until there is only the DROID SERGEANT left. The SERGEANT starts to run but is pulled back to QUI-GON by the Force, until finally he is dispatched by the JEDI.

JAR JAR: Yousa guys bombad!

QUEEN AMIDALA and the OTHERS are amazed. JAR JAR is getting used to this. They move between two buildings.

QUI-GON: Your Highness, we are the Ambassadors for the Supreme Chancellor.
BIBBLE: Your negotiations seem to have failed, Ambassador.
QUI-GON: The negotiations never took place. Your Highness, we must make contact with the Republic.

CAPTAIN PANAKA steps forward.

CAPT. PANAKA: They've knocked out all our communications.
QUI-GON: Do you have transports?
CAPT. PANAKA: In the main hangar. This way.

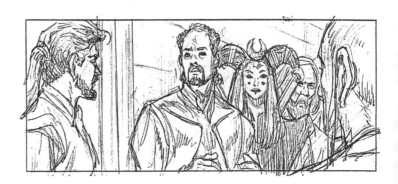

THEY disappear down an alleyway as the ALARMS are sounded.

INT. CENTRAL HANGAR—HALLWAY—DAY

CAPTAIN PANAKA cracks open a side door to the central hangar. QUI-GON looks in over his shoulder. OBI-WAN, JAR JAR, and the rest of the group are behind him. They see several Naboo spacecraft guarded by about FIFTY BATTLE DROIDS. ALARMS can be heard in the distance.

CAPT. PANAKA: There are too many of them.
QUI-GON: That won't be a problem. *(to Amidala)* Your Highness, under the circumstances, I suggest you come to Coruscant with us.
AMIDALA: Thank you, Ambassador, but my place is here with my people.
QUI-GON: They will kill you if you stay.
BIBBLE: They wouldn't dare.
CAPT. PANAKA: They need her to sign a treaty to make this invasion of theirs legal. They can't afford to kill her.
QUI-GON: The situation here is not what it seems. There is something else behind all this, Your Highness. There is no logic in the Federation's move here. My feelings tell me they will destroy you.
BIBBLE: Please, Your Highness, reconsider. Our only hope is for the Senate to side with us... Senator Palpatine will need your help.
CAPT. PANAKA: Getting past their blockade is impossible, Your Highness. Any attempt to escape will be dangerous.
BIBBLE: Your Highness, I will stay here and do what I can...They will have to retain the Council of Governors in order to maintain control. But you must leave...

The QUEEN turns to PADMÉ and EIRTAÉ.

AMIDALA: Either choice presents a great risk...to all of us...
PADMÉ: We are brave, Your Highness.
QUI-GON: If you are to leave, Your Highness, it must be now.
AMIDALA: Then, I will plead our case before the Senate. *(to Bibble)* Be careful, Governor.

INT. CENTRAL HANGAR—DAY

The door opens to the main hangar. QUI-GON, OBI-WAN, JAR JAR, CAPTAIN PANAKA, TWO GUARDS, and THREE HANDMAIDENS (PADMÉ, EIRTAÉ, RABÉ), followed by QUEEN AMIDALA, head for a sleek chrome spacecraft. SIO BIBBLE, YANÉ, and SACHÉ stay behind. The HANDMAIDENS begin to cry.

CAPT. PANAKA: We need to free those pilots.

CAPTAIN PANAKA points to TWENTY GUARDS, GROUND CREW, and PILOTS held in a corner by SIX BATTLE DROIDS.

OBI-WAN: I'll take care of that.

OBI-WAN heads toward the group of captured pilots. QUI-GON and the QUEEN, CAPTAIN PANAKA, JAR JAR, and the rest of the GROUP approach the GUARDS at the ramp of the Naboo craft.

GUARD DROID: Where are you going?
QUI-GON: I'm Ambassador for the Supreme Chancellor, and I'm taking these people to Coruscant.
DROID GUARD: You're under arrest!

The DROID GUARD draws his weapon, but before any of the DROIDS can fire, they are cut down. OTHER DROIDS run to their aid. OBI-WAN attacks the GUARDS around the PILOTS. QUI-GON stands, fighting off DROIDS as the OTHERS rush on board the spacecraft. OBI-WAN, the FREED PILOTS (including RIC OLIÉ), GUARDS and GROUND CREW MEMBERS rush on board the ship. The OTHER PILOTS and GUARDS race to SIO BIBBLE. After everyone has made it onto the ship, QUI-GON jumps on board. ALARMS sound. MORE DROIDS rush into the hangar and fire as the ship takes off.

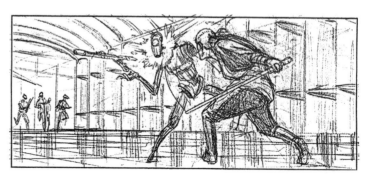

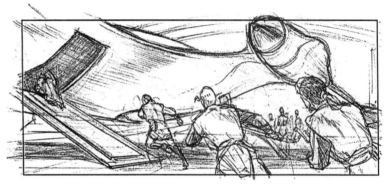

EXT. THEED—HANGAR ENTRY—DAY (FX)

The ship exits the hangar. BATTLE DROIDS standing in the hangar shoot at them.

EXT. SPACE (FX)

The sleek spacecraft speeds away from the planet of Naboo and heads for the deadly Federation blockade.

INT. NABOO SPACECRAFT—COCKPIT

The PILOT, RIC OLIÉ, navigates toward the massive battleship. QUI-GON and CAPTAIN PANAKA watch.

RIC OLIÉ: ...our communications are still jammed.

INT. NABOO SPACECRAFT—DROID HOLD

JAR JAR is led into a low, cramped doorway by OBI-WAN.

OBI-WAN: Now stay here, and keep out of trouble.

OBI-WAN closes the door.
 JAR JAR looks around and sees a long row of five short, dome-topped ASTRO DROIDS (R-2 units). They all look alike, except for their paint color, and they seem to be shut down.

JAR JAR: Ello, boyos. *(no response)* Disa wanna longo trip ...hey?

JAR JAR taps a bright red R-2 UNIT on the head, and its head pops up a bit. He lets out a gasp as he lifts the head.

JAR JAR: *(Cont'd)* Tis opens?...Oooops!

Many springs and things come flying out. JAR JAR quickly closes it again, very embarrassed.

JAR JAR: *(Cont'd)* Yoi! Just yoken!

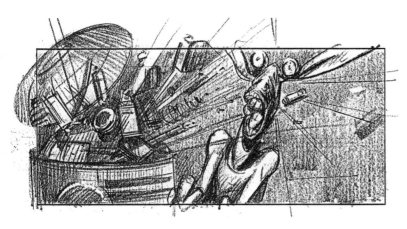

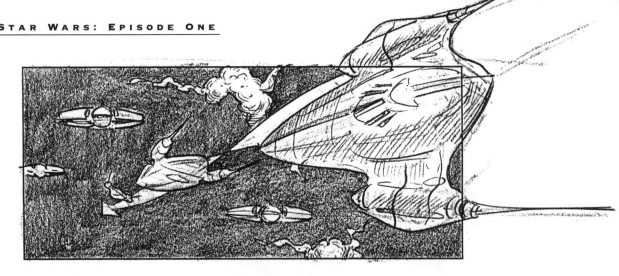

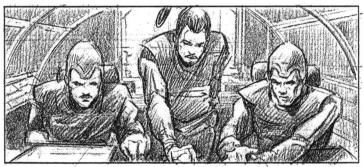

EXT. SPACE BATTLE (FX)

The Naboo spacecraft, surrounded by EXPLOSIONS, heads even closer to the massive Federation battleships.

INT. NABOO SPACECRAFT—COCKPIT

RIC OLIÉ: There's the blockade, hang on.

ALARM SOUNDS fill the cockpit as OBI-WAN enters.

RIC OLIÉ: *(Cont'd)* The shield generator's been hit. Our deflector shields can't withstand this. Power down... Hopefully the repair droids can fix it.

INT. NABOO SPACECRAFT—DROID HOLD (FX)

The lights go on, and all the DROIDS are activated. DROIDS rush to an exterior air lock, except for the red one, who runs into a wall. JAR JAR holds on for dear life.

One LITTLE BLUE ASTRO DROID, who is especially dedicated, lets out a loud screech as he passes JAR JAR, causing the Gungan to jump.

The LITTLE DROID enters an air lock and is ejected onto the exterior of the ship.

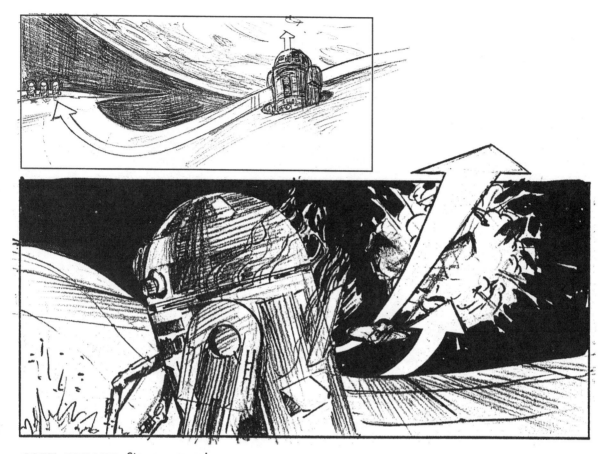

CAPT. PANAKA: Stay on course!

QUI-GON: Do you have a cloaking device?

CAPT. PANAKA: No, this is not a warship...we have no weapons. We're a non-violent people...that is why the Federation was brave enough to attack us.

RIC OLIÉ: We won't make it. The shields are gone.

EXT. NABOO SPACECRAFT—FEDERATION BATTLESHIP—SPACE (FX)

The DROIDS pop onto the exterior of the Naboo spacecraft; the ship races across the surface of the massive Federation battleship, as its guns blast TWO ASTRO DROIDS.

OBI-WAN: We're losing droids fast.

CAPT. PANAKA: If they can't get those shield generators fixed, we will be sitting ducks.

RIC OLIÉ: The shields are gone.

EXT. NABOO SPACECRAFT—ENGINES—SPACE (FX)

The Federation battleship blows away ONE MORE ASTRO DROID. The BLUE DROID connects some wires, causing sparks to fly.

RIC OLIÉ: Power's back! That little droid did it. He bypassed the main power drive. Deflector shields up, at maximum.

The lone BLUE DROID finishes his repairs and goes back into the ship.

The Naboo spacecraft races away from the Federation battleship.

INT. NABOO SPACECRAFT—COCKPIT

OBI-WAN is in the co-pilot's seat working with RIC OLIÉ. QUI-GON and CAPTAIN PANAKA stand behind them.

RIC OLIÉ: There's not enough power to get us to Coruscant...the hyperdrive is leaking.
QUI-GON: We'll have to land somewhere to refuel and repair the ship.

QUI-GON studies a star chart on a monitor.

OBI-WAN: Here, Master. Tatooine... It's small, out of the way, poor... The Trade Federation has no presence there.
CAPT. PANAKA: How can you be sure?
QUI-GON: It's controlled by the Hutts...
CAPT. PANAKA: The Hutts??
OBI-WAN: It's risky...but there's no alternative.
CAPT. PANAKA: You can't take Her Royal Highness there! The Hutts are gangsters... If they discovered her...
QUI-GON: ...It would be no different than if we landed on a system controlled by the Federation...except the Hutts aren't looking for her, which gives us an advantage.

CAPTAIN PANAKA takes a deep breath in frustration.

EXT. SPACE—NABOO STARSHIP (FX)

The Naboo starship races away.

INT. FEDERATION BATTLESHIP—CONFERENCE ROOM

NUTE and RUNE sit around a conference table with a hologram of DARTH SIDIOUS.

NUTE: We control all the cities in the North and are searching for any other settlements...

DARTH SIDIOUS: Destroy all high-ranking officials, Viceroy...slowly...quietly. And Queen Amidala, has she signed the treaty?

NUTE: She has disappeared, My Lord. One Naboo cruiser got past the blockade.

DARTH SIDIOUS: Viceroy, find her! I want that treaty signed.

NUTE: My Lord, it's impossible to locate the ship. It's out of our range.

DARTH SIDIOUS: ...not for a Sith...

A second SITH LORD appears behind DARTH SIDIOUS.

DARTH SIDIOUS: *(Cont'd)*...Viceroy, this is my apprentice, Lord Maul. He will find your lost ship.

NUTE: Yes, My Lord.

The hologram fades off.

NUTE: *(Cont'd)* This is getting out of hand...now there are two of them.

RUNE: We should not have made this bargain. What will happen when the Jedi become aware of these Sith Lords?

INT. NABOO SPACECRAFT—QUEEN'S CHAMBERS

QUI-GON, OBI-WAN, CAPTAIN PANAKA, and the LITTLE BLUE DROID stand before QUEEN AMIDALA and her THREE HANDMAIDENS, PADMÉ, EIRTAÉ and RABÉ.

CAPT. PANAKA: ...An extremely well put together little droid. Without a doubt, it saved the ship, as well as our lives.

AMIDALA: It is to be commended...what is its number?

The LITTLE BLUE DROID lets out a series of beeps. CAPTAIN PANAKA leans over and scrapes some dirt off of the side of the DROID and reads the number:

CAPT. PANAKA: R2-D2, Your Highness.

AMIDALA: Thank you, Artoo-Detoo. You have proven to be very loyal...Padmé!

PADMÉ bows before the QUEEN.

AMIDALA: *(Cont'd)* Clean this droid up the best you can. It deserves our gratitude...*(to Panaka)* Continue, Captain.

CAPTAIN PANAKA looks nervously to OBI-WAN and QUI-GON.

QUI-GON: Your Highness, we are heading for a remote planet called Tatooine. It is a system far beyond the reach of the Trade Federation. There we will be able to make needed repairs, then travel on to Coruscant.

CAPT. PANAKA: Your Highness, Tatooine is very dangerous. It's controlled by an alliance of gangs called the Hutts. I do not agree with the Jedi on this.

QUI-GON: You must trust my judgement, Your Highness.

AMIDALA and PADMÉ exchange looks. PADMÉ moves next to the DROID.

INT. NABOO SPACECRAFT—MAIN AREA

PADMÉ sits in the Main Area, cleaning R2-D2, the brave little Astro Droid. JAR JAR pops out of an open door.

JAR JAR: Hidoe!

Both PADMÉ and ARTOO jump and let out a little SCREAM. The Gungan is embarrassed that he frightened them.

JAR JAR: *(Cont'd)* Sorry, no meanen to scare yousa.

PADMÉ: That's all right.

JAR JAR: I scovered oily back dare. Needen it?
PADMÉ: Thank you. This little guy is quite a mess.

JAR JAR hands PADMÉ the oil can.

JAR JAR: Mesa Ja Ja Binkssss...
PADMÉ: I'm Padmé, I attend Her Highness. You're a Gungan, aren't you? *(Jar Jar nods)* How did you end up here with us?
JAR JAR: My no know...mesa day starten pitty okeyday witda brisky morning munchen. Den boom...getten berry skeered, un grabben dat Jedi, and before mesa knowen it...pow! Mesa here. *(he shrugs)*...getten berry berry skeered.

ARTOO BEEPS a sympathetic beep.

INT. NABOO SPACECRAFT—COCKPIT

OBI-WAN, QUI-GON, and CAPTAIN PANAKA watch over RIC OLIÉ'S shoulder. A large yellow planet appears directly ahead. RIC OLIÉ searches his scopes.

OBI-WAN: That's it. Tatooine.
RIC OLIÉ: There's a settlement...a spaceport, looks like.
QUI-GON: Land near the outskirts. We don't want to attract any attention.

EXT. TATOOINE—SPACE (FX)

The ship heads toward the planet of Tatooine.

EXT. TATOOINE—DESERT—NABOO SPACECRAFT—DAY (FX)

The Naboo spacecraft lands in the desert in a swirl of dust. The spaceport of Mos Espa is seen in the distance.

INT. NABOO SPACECRAFT—MAIN AREA

OBI-WAN is hoisting the hyperdrive out of a floor panel. JAR JAR rushes up to him and falls to his knees.

JAR JAR: Obi-Wan, sire, pleeeese, no mesa go!
OBI-WAN: Sorry, Qui-Gon's right. You'll make things less obvious.

JAR JAR walks back to ARTOO in the hallway as QUI-GON (dressed as a farmer) enters the main area.

OBI-WAN: *(Cont'd)* The hyperdrive generator is gone. We will need a new one.

QUI-GON moves closer to OBI-WAN and speaks quietly to him.

QUI-GON: Don't let them send any transmissions. Be wary... I sense a disturbance in the Force.
OBI-WAN: I feel it also, Master.

QUI-GON goes into the hallway to meet up with ARTOO and JAR JAR. They head to the exit ramp.

EXT. TATOOINE—DESERT—SPACESHIP—DAY

They start their trek across the desert toward the city of Mos Espa. In the distance, a strange looking caravan makes its way toward the spaceport.

JAR JAR: Dis sun doen murder tada skin.

From the spaceship, CAPTAIN PANAKA and PADMÉ run toward them.

CAPT. PANAKA: Wait!

QUI-GON stops as they catch up. PADMÉ is dressed in rough peasant's garb.

CAPT. PANAKA: *(Cont'd)* Her Highness commands you to take her handmaiden with you. She wishes for her to observe the local...
QUI-GON: No more commands from Her Highness today, Captain. This spaceport is not going to be pleasant...
CAPT. PANAKA: The Queen wishes it. She is curious about this planet.
PADMÉ: I've been trained in defense... I can take care of myself.
CAPT. PANAKA: Don't make me go back and tell her you refuse.

QUI-GON: I don't have time to argue. But this is not a good idea. Stay close to me.

He gives PADMÉ a stern look.

EXT. MOS ESPA—STREET—DAY

The little GROUP walks down the main street of Mos Espa. They pass dangerous looking citizens of all types. PADMÉ looks around in awe at this exotic environment.

QUI-GON: ...moisture farms for the most part, but also a few indigenous tribes and scavengers. The few spaceports like this one are havens for those who do not wish to be found...
PADMÉ: ...like us.

JAR JAR is in a constant state of panic. ARTOO whistles along, with perfect confidence.

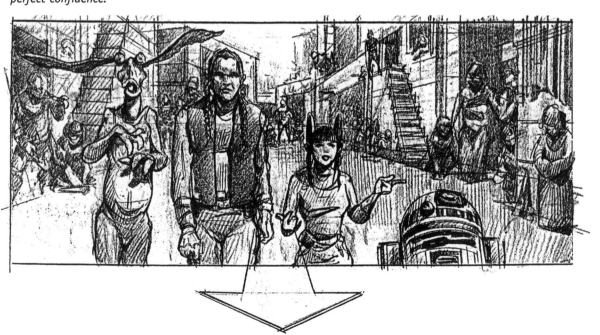

JAR JAR: Dissen berry berry bad. *(steps in ooze)* Ooooh... icky...icky...goo.

EXT. MOS ESPA—JUNK DEALER PLAZA—DAY

The GROUP comes to a little plaza surrounded by several junk spaceship dealers.

QUI-GON: We'll try one of the smaller dealers.

They head for a little junk shop that has a huge pile of broken spaceships stacked up behind it.

INT. WATTO'S JUNK SHOP—DAY

QUI-GON, JAR JAR, PADMÉ, and ARTOO enter the dingy junk shop and are greeted by WATTO, a pudgy blue alien who flies on short little wings like a hummingbird.

WATTO: *(subtitled)* Hi chuba da nago? *(What do you want?)*
QUI-GON: I need parts for a J-type 327 Nubian.
WATTO: Ah yes, ah yes. Nubian. We have lots of that. What kinda junk? *(subtitled)* Peedunkel! Naba dee unko. *(Boy, get in here! Now!)*
QUI-GON: My droid here has a readout of what I need.

A disheveled boy, ANAKIN SKYWALKER, runs in from the junk yard. He is about nine years old, very dirty, and dressed in rags. WATTO raises a hand, and ANAKIN flinches.

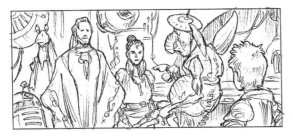 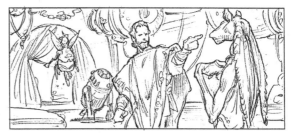

WATTO: *(subtitled)* Coona tee-tocky malia? *(What took you so long?)*

ANAKIN: *(subtitled)* Mel tassa cho-passa... *(I was cleaning the bin like you...)*

WATTO: *(subtitled)* Chut-Chut! Ganda doe wallya. *(Never mind! Watch the store.)* Me dwana no bata. *(I've got some selling to do here.)* *(to Qui-Gon)* Soooo, let me take-a thee out back. Ni you'll find what you need.

ARTOO and QUI-GON follow WATTO toward the junk yard, leaving JAR JAR with PADMÉ and the young boy ANAKIN. JAR JAR picks up a gizmo, trying to figure out its purpose. QUI-GON takes the part out of his hand and puts it back.

QUI-GON: Don't touch anything.

JAR JAR makes a rude face to QUI-GON's back and sticks out his long tongue. ANAKIN sits on the counter, pretending to clean a part, staring at PADMÉ. She is the most beautiful creature he has ever seen in his life. PADMÉ is a little embarrassed by his stare, but she musters up an amused smile. Finally, he gets the courage to speak.

ANAKIN: Are you an angel?
PADMÉ: What?
ANAKIN: An angel. I've heard the deep space pilots talk about them. They live on the Moons of Iego, I think. They are the most beautiful creatures in the universe. They are good and kind, and so pretty they make even the most hardened spice pirate cry.

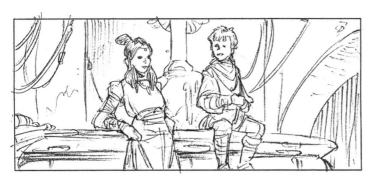

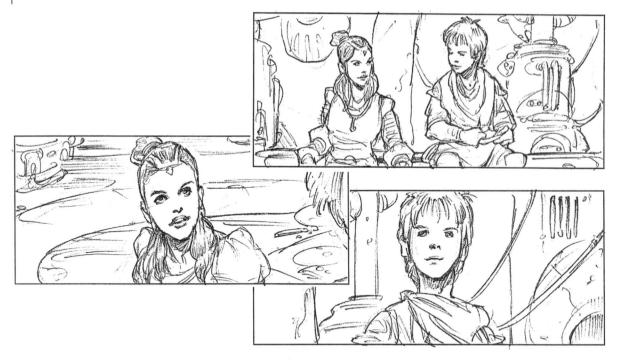

PADMÉ looks at him, not knowing what to say.

PADMÉ: I've never heard of angels.

ANAKIN: You must be one...maybe you just don't know it.

PADMÉ: You're a funny little boy. How do you know so much?

ANAKIN: I listen to all the traders and pilots who come through here. I'm a pilot, you know, and someday, I'm going to fly away from this place.

PADMÉ: You're a pilot?

ANAKIN: All my life.

PADMÉ: *(amused)* Have you been here long?

ANAKIN: Since I was very little, three, I think. My Mom and I were sold to Gardulla the Hutt, but she lost us, betting on the Podraces, to Watto, who's a lot better master than Gardulla, I think.

PADMÉ: You're...a slave?

ANAKIN looks at PADMÉ defiantly.

ANAKIN: I am a person! My name is Anakin.

PADMÉ: I'm sorry. I don't fully understand. *(looking around)* This is a strange world to me.

ANAKIN studies her intently.

ANAKIN: You are a strange girl to me.

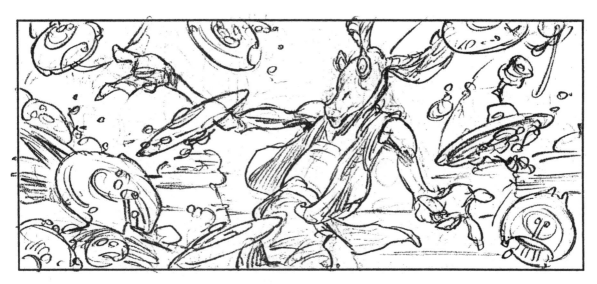

JAR JAR pushes the nose on what appears to be a LITTLE DROID, and it instantly comes to life, grows legs and arms, and starts marching around, knocking over everything. JAR JAR holds on but can't stop it.

ANAKIN: *(Cont'd)* Hit the nose!

JAR JAR hits the nose, and the DROID collapses back into its original state. ANAKIN and PADMÉ laugh. ANAKIN watches PADMÉ straighten her hair.

EXT. WATTO'S JUNK YARD—BEHIND SHOP—DAY

WATTO reads a small portable monitor he is holding. He stands before a hyperdrive.

WATTO: ...Here it is...a T-14 hyperdrive generator!! Thee in luck, I'm the only one hereabouts who has one...but thee might as well buy a new ship. It would be cheaper, I think... Saying of which, how's thee going to pay for all this?

QUI-GON: I have 20,000 Republic dataries...

WATTO: Republic credits?!? Republic credits are no good out here. I needa something more real...

QUI-GON: I don't have anything else. *(raising his hand)* But credits will do fine.

WATTO: No they won'ta.

QUI-GON, using his mind power, waves his hand again.

QUI-GON: Credits will do fine.

WATTO: No they won'ta. What you think you're some kinda Jedi, waving your hand around like that? I'm a Toydarian. Mind tricks don'ta work on me—only money. No money, no parts! No deal! And no one else has a T-14 hyperdrive, I promise you that.

INT. WATTO'S JUNK SHOP—DAY

JAR JAR pulls a part out of a stack of parts to inspect it, and they all come tumbling down. He struggles to catch them, only to knock more down. ANAKIN and PADMÉ are oblivious.

ANAKIN: …wouldn't have lasted long if I weren't so good at fixing things. I'm making my own droid…

QUI-GON hurries into the shop, followed by ARTOO.

QUI-GON: We're leaving.

JAR JAR follows QUI-GON. PADMÉ gives ANAKIN a loving look.

PADMÉ: I'm glad I met you,…ah…
ANAKIN: …Anakin.
PADMÉ: Anakin.
ANAKIN: Anakin Skywalker.
PADMÉ: Padmé Naberrie.

PADMÉ turns, and ANAKIN looks sad as he watches her leave.

ANAKIN: I'm glad I met you too!

WATTO enters from the junk yard, shaking his head.

WATTO: *(subtitled)* Ootmians! Tinka me chasa hopoe ma booty na nolia. *(Outlanders! They think because we live so far from the center, we don't know nothing.)*
ANAKIN: *(subtitled)* La lova num botaffa. *(They seemed nice to me.)*
WATTO: *(subtitled)* Fweepa niaga. Tolpa da bunky dunko. *(Clean the racks, then you can go home.)*

ANAKIN lets out a "yippee" and runs out the back.

EXT. MOS ESPA—STREET—ALCOVE—DAY

QUI-GON, ARTOO, JAR JAR, and PADMÉ have found a quiet spot between two buildings. The busy street beyond is filled with dangerous looking creatures. QUI-GON is talking on his comlink, while JAR JAR nervously watches the street. OBI-WAN is in the Main Hold of the Naboo craft.

QUI-GON: …Obi-Wan, you're sure there isn't anything of value left on board?
OBI-WAN: *(V.O.)* A few containers of supplies, the Queen's wardrobe, maybe. Not enough for you to barter with. Not in the amounts you're talking about.
QUI-GON: All right. Another solution will present itself. I'll check back.

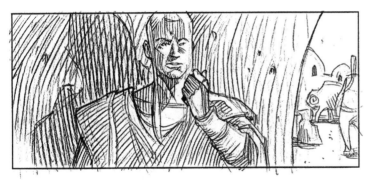

QUI-GON puts his comlink away and starts out into the main street. JAR JAR grabs his arm.

JAR JAR: Noah gain...da beings hereabouts cawazy. Wesa be robbed un crunched.

QUI-GON: Not likely. We have nothing of value, that's our problem.

EXT. MOS ESPA—STREET—MARKET—DAY

QUI-GON, PADMÉ, JAR JAR, and ARTOO move out into the street. JAR JAR is walking behind the others. They walk by an outdoor cafe filled with a rough gang of aliens, one of which is especially ugly, SEBULBA, a spider-like creature.

JAR JAR stops for a moment in front of a stall selling dead frogs hanging on a wire. He looks around to see if anyone is looking, then sticks out his tongue, and gets hold of one, pulling it into his mouth. Unfortunately, the frog is tied tightly to the wire. The vendor suddenly appears.

VENDOR: Hey, that will be seven truguts!!

JAR JAR opens his mouth in surprise, and the frog snaps away, ricochets around the market, and lands in Sebulba's soup, splashing him. As JAR JAR moves away from the VENDOR, SEBULBA jumps up on the table and grabs the hapless Gungan.

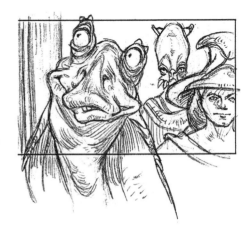

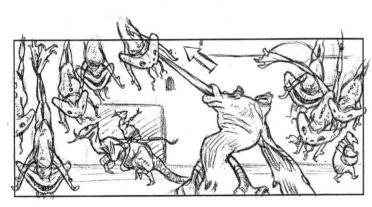

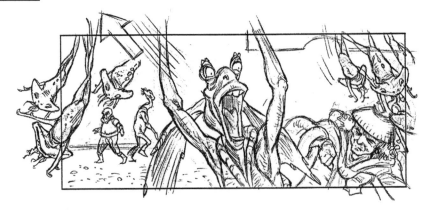

SEBULBA: *(subtitled)* Chuba!! *(You!!)*
JAR JAR: Who, mesa??
SEBULBA: *(subtitled)* Ni chuba na?? *(Is this yours??)*

SEBULBA holds the frog up to the Gungan threateningly. SEVERAL OTHER CREATURES start to gather. SEBULBA shoves JAR JAR to the ground. The Gungan desperately tries to scramble to safety.

JAR JAR: *(to himself)* Why mesa always da one??
ANAKIN: *(V.O.)* Because you're afraid.

JAR JAR turns to see ANAKIN pushing his way next to him. The boy stands up to SEBULBA in a very self-assured way.

ANAKIN: *(subtitled)* Chess ko, Sebulba...Coo wolpa tooney rana. *(Careful, Sebulba...This one's very well connected.)*

SEBULBA stops his assault on JAR JAR and turns to ANAKIN.

SEBULBA: *(subtitled)* Tooney rana nu pratta dunko, shag. *(Connected?? Whada you mean, slave?)*
ANAKIN: *(subtitled)* Oh da Hutt...cha porko ootman geesa...me

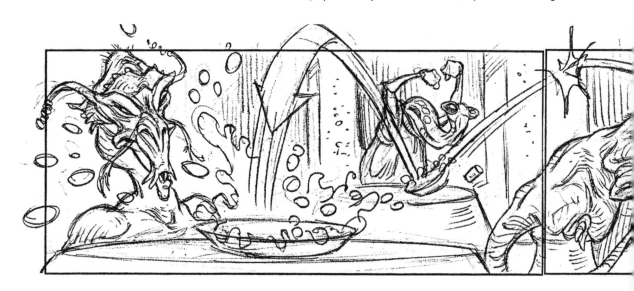

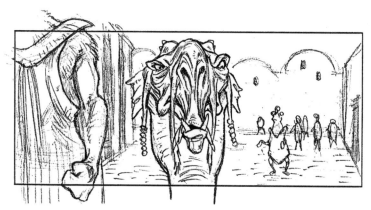

teesa rodda co pana pee choppa chawa. *(As in Hutt...big time outlander, this one... I'd hate to see you diced before we race again.)*
SEBULBA: *(subtitled)* Neek me chawa, wermo, mo killee ma klounkee. *(Next time we race, wermo, it will be the end of you!)* Una notu wo shag, me wompity du pom pom. *(If you weren't a slave, I'd squash you right now.)*

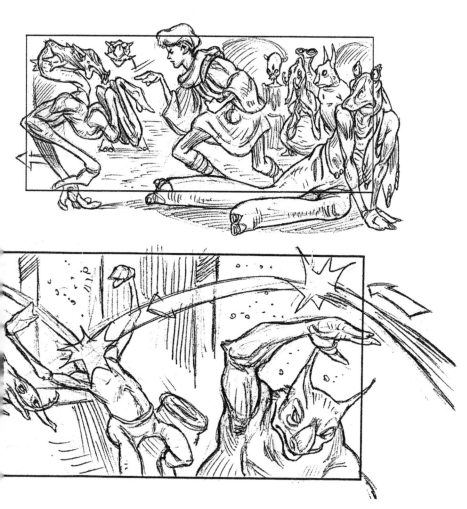

SEBULBA turns away.

ANAKIN: *(subtitled)* Eh, chee bana do mullee ra. *(Yeah, it'd be a pity if you had to pay for me.)*

QUI-GON, PADMÉ, and ARTOO arrive.

ANAKIN: *(Cont'd)* Hi! Your buddy here was about to be turned into orange goo. He picked a fight with a Dug. An especially dangerous Dug called Sebulba.
JAR JAR: Nosir, nosir. Mesa hate crunchen. Dat's da last ting mesa wanten.
QUI-GON: Nevertheless, the boy is right...you were heading for trouble. Thank you, my young friend.

PADMÉ looks at ANAKIN and smiles; he smiles back. They start walking down the crowded street.

JAR JAR: Mesa doen nutten!
ANAKIN: Fear attracts the fearful. He was trying to overcome his fear by squashing you...be less afraid.
PADMÉ: And that works for you.
ANAKIN: To a point. *(he smiles)*

EXT. TATOOINE—DESERT—SPACESHIP—DAY

OBI-WAN stands in front of the Naboo spacecraft as the wind picks up and begins to whip at his robe. CAPTAIN PANAKA exits the ship and joins him.

OBI-WAN: This storm's going to slow them down.
CAPT. PANAKA: It looks pretty bad. We'd better seal the ship.

CAPTAIN PANAKA's comlink sounds off.

CAPT. PANAKA: *(Cont'd)* Yes?
RIC OLIÉ: *(V.O.)* We're receiving a message from home.
CAPT. PANAKA: We'll be right there.

EXT. MOS ESPA—STREET—FRUIT STAND—DAY

ANAKIN and the GROUP stop at a fruit stand run by a jolly, but very poor, old lady named JIRA.

ANAKIN: How are you feeling today, Jira?
JIRA: The heat's never been kind to me, you know, Annie!
ANAKIN: Guess what? I've found that cooling unit I've been searching for. It's pretty beat up, but I'll have it fixed up for you in no time, I promise.
JIRA: You're a fine boy, Annie.
ANAKIN: I'll take four pallies today. *(to Padmé)* You'll like these...

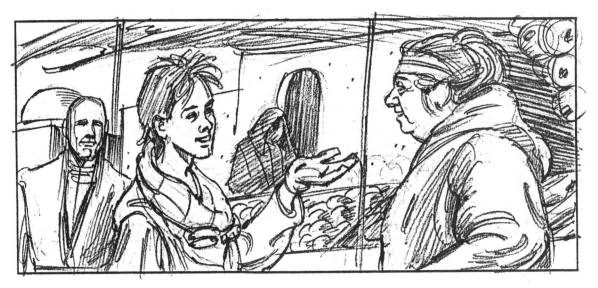

ANAKIN reaches in his pocket and comes up with three coins. He drops one. QUI-GON picks it up, revealing for a moment, his lightsaber.

ANAKIN: *(Cont'd)* Whoops, I thought I had more... Make that three, I'm not hungry.

The winds pick up. SHOP OWNERS are starting to close up their shops as JIRA gives them their pallies.

JIRA: Gracious, my bones are aching...storm's coming on, Annie. You'd better get home quick.
ANAKIN: *(to Qui-Gon)* Do you have shelter?
QUI-GON: We'll head back to our ship.
ANAKIN: Is it far?
PADMÉ: On the outskirts.
ANAKIN: You'll never reach the outskirts in time...sandstorms are very, very dangerous. Come with me. Hurry!

The GROUP follows ANAKIN as he rushes down the windy street.

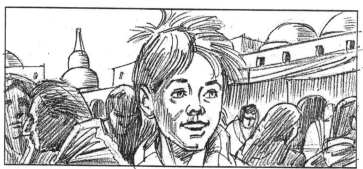

EXT. MOS ESPA—SLAVE QUARTERS—STREET—SANDSTORM—DAY

The wind is blowing hard as QUI-GON, JAR JAR, and PADMÉ follow ANAKIN down the street and into a slave hovel.

INT. ANAKIN'S HOVEL—MAIN ROOM—DAY

QUI-GON, JAR JAR, ARTOO, and PADMÉ enter a small living space.

ANAKIN: Mom! Mom! I'm home.
JAR JAR: Dissen cozy.

Anakin's mother, SHMI SKYWALKER, a warm, friendly woman of forty, enters from her work area and is startled to see the room full of people.

SHMI: Oh, my!! Annie, what's this??
ANAKIN: These are my friends, Mom. This is Padmé, and...gee, I don't know any of your names.
QUI-GON: I'm Qui-Gon Jinn, and this is Jar Jar Binks.

ARTOO lets out a little beep.

PADMÉ: ...and our droid, Artoo-Detoo.
ANAKIN: I'm building a droid. You wanna see?
SHMI: Anakin! Why are they here?
ANAKIN: A sandstorm, Mom. Listen.

The wind HOWLS outside.

QUI-GON: Your son was kind enough to offer us shelter.
ANAKIN: Come on! Let me show you Threepio!

ANAKIN leads PADMÉ into the other room. ARTOO follows, beeping all the way.
 QUI-GON takes five small capsules from his utility belt and hands them to SHMI.

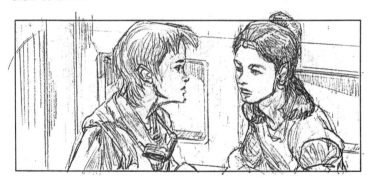

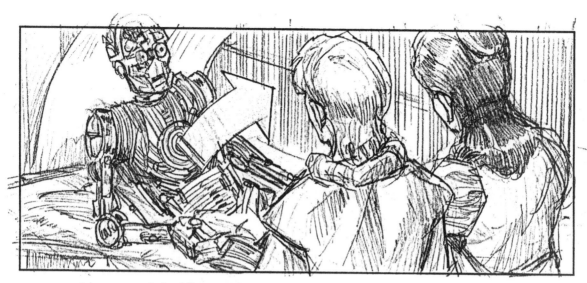

QUI-GON: I have enough food for a meal.

SHMI: Oh, thank you. Thank you so much. I'm sorry if I was abrupt. I'll never get used to Anakin's surprises.

QUI-GON: He's a very special boy.

SHMI looks at him as if he's discovered a secret.

SHMI: Yes, I know.

INT. ANAKIN'S HOVEL—BEDROOM—DAY

ANAKIN shows off his ANDROID, which is lying on his work bench. There is one eye in the head; the body, arms, and legs have no outer coverings.

ANAKIN: Isn't he great?! He's not finished yet.

PADMÉ: He's wonderful!

ANAKIN: You really like him? He's a protocol droid...to help Mom. Watch!

ANAKIN pushes a switch, and the DROID sits up. Anakin rushes around, grabs an eye and puts it in one of the sockets.

THREEPIO: How do you do, I am See-Threepio, Human Cyborg Relations. How might I serve you?

PADMÉ: He's perfect.

ANAKIN: When the storm is over, you can see my racer. I'm building a Podracer!

PADMÉ smiles at his enthusiasm. ARTOO lets out a flurry of beeps and whistles.

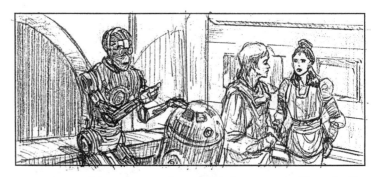

THREEPIO: I beg your pardon...what do you mean I'm naked?

ARTOO beeps.

THREEPIO: *(Cont'd)* My parts are showing? Oh, my goodness. How embarrassing!

INT. NABOO SPACECRAFT—QUEEN'S CHAMBERS

AMIDALA, EIRTAÉ, RABÉ and OBI-WAN watch a very bad transmission of a SIO BIBBLE hologram.

BIBBLE:cut off all food supplies until you return...the death toll is catastrophic...we must bow to their wishes, Your Highness... Please tell us what to do! If you can hear us, Your Highness, you must contact me...

AMIDALA looks upset...almost nervous.

OBI-WAN: It's a trick. Send no reply... Send no transmissions of any kind.

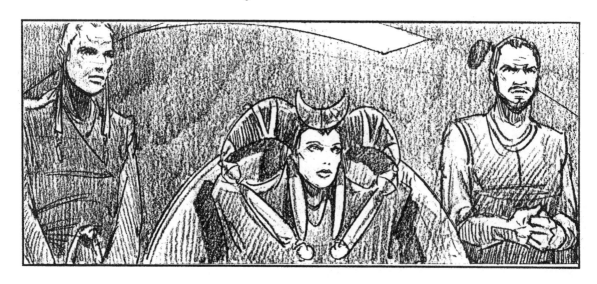

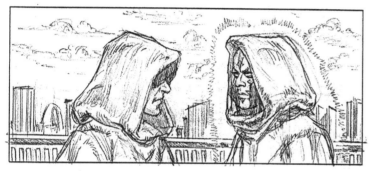

INT. ANAKIN'S HOVEL—MAIN ROOM—DAY

QUI-GON listens to his comlink. OBI-WAN is in the cockpit.

OBI-WAN: ...the Queen is upset....but absolutely no reply was sent.
QUI-GON: It sounds like bait to establish a connection trace.
OBI-WAN: What if it is true and the people are dying?
QUI-GON: Either way, we're running out of time.

EXT. CORUSCANT—BALCONY OVERLOOKING CITY—NIGHT

DARTH SIDIOUS and DARTH MAUL look out over the vast city.

DARTH MAUL: Tatooine is sparsely populated. If the trace was correct, I will find them quickly, Master.
DARTH SIDIOUS: Move against the Jedi first...you will then have no difficulty taking the Queen back to Naboo, where she will sign the treaty.
DARTH MAUL: At last we will reveal ourselves to the Jedi. At last we will have revenge.
DARTH SIDIOUS: You have been well trained, my young apprentice, they will be no match for you. It is too late for them to stop us now. Everything is going as planned. The Republic will soon be in my control.

The hologram of DARTH MAUL fades off as DARTH SIDIOUS looks out over the city.

EXT. MOS ESPA—SANDSTORM—DAY

The giant sandstorm engulfs the town, including the Naboo space-ship on the outskirts; the city center, where Watto's shop is; and the slave quarters, where drifts of sand begin building up against Anakin's house.

INT. ANAKIN'S HOVEL—MAIN ROOM—DAY

QUI-GON, ANAKIN, SHMI, JAR JAR, and PADMÉ are seated around a makeshift table, having dinner as the wind howls outside.
 JAR JAR slurps his soup rather loudly. Everyone looks at him. He turns a little brighter red.

SHMI: All slaves have transmitters placed inside their bodies somewhere.
ANAKIN: I've been working on a scanner to try to locate them, but no luck.
SHMI: Any attempt to escape...
ANAKIN: ...and they blow you up...poof!

PADMÉ and JAR JAR are horrified.

JAR JAR: How wude.
PADMÉ: I can't believe there is still slavery in the galaxy. The Republic's anti-slavery laws...
SHMI: The Republic doesn't exist out here...we must survive on our own.

An awkward silence. ANAKIN attempts to end the embarrassment.

ANAKIN: Have you ever seen a Podrace?

PADMÉ shakes her head no. She notices the concern of SHMI. JAR JAR snatches some food from a bowl at the other end of the table with his tongue. QUI-GON gives him a dirty look.

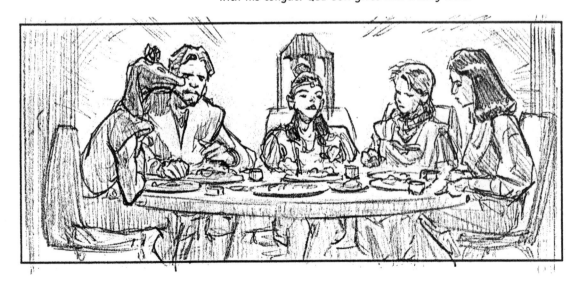

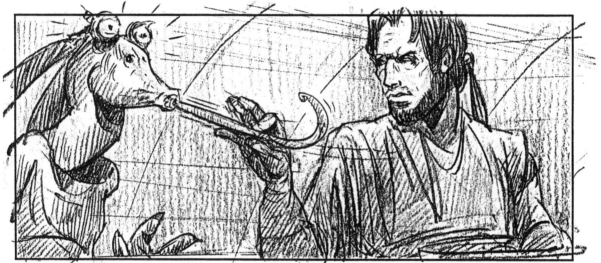

QUI-GON: They have Podracing on Malastare. Very fast, very dangerous.

ANAKIN: I'm the only human who can do it.

SHMI looks askance at her son.

ANAKIN: *(Cont'd)* Mom, what? I'm not bragging. It's true. Watto says he's never heard of a human doing it.

QUI-GON: You must have Jedi reflexes if you race Pods.

ANAKIN smiles. JAR JAR attempts to snare another bit of food from the bowl with his tongue, but QUI-GON, in a flash, grabs it between his thumb and forefinger. JAR JAR is startled.

QUI-GON: *(Cont'd)* Don't do that again.

JAR JAR tries to acknowledge with some silly mumbling. QUI-GON lets go of the tongue, and it snaps back into JAR JAR's mouth.

ANAKIN: I...I was wondering...something...

QUI-GON: What?

ANAKIN: Well, ahhh...you're a Jedi Knight, aren't you?

QUI-GON: What makes you think that?

ANAKIN: I saw your laser sword. Only Jedi carry that kind of weapon.

QUI-GON leans back and slowly smiles.

QUI-GON: Perhaps I killed a Jedi and stole it from him.

ANAKIN: I don't think so... No one can kill a Jedi Knight.

QUI-GON: I wish that were so...

ANAKIN: I had a dream I was a Jedi. I came back here and freed all the slaves...have you come to free us?

QUI-GON: No, I'm afraid not...

ANAKIN: I think you have...why else would you be here?

QUI-GON thinks for a moment.

QUI-GON: I can see there's no fooling you... *(leans forward)* You mustn't let anyone know about us...we're on our way to Coruscant, the central system in the Republic, on a very important mission, and it must be kept secret.

ANAKIN: Coruscant...wow...how did you end up out here in the outer rim?

PADMÉ: Our ship was damaged, and we're stranded here until we can repair it.

ANAKIN: I can help! I can fix anything!

QUI-GON: I believe you can, but our first job is to acquire the parts we need...

JAR JAR: Wit no-nutten mula to trade.

PADMÉ: These junk dealers must have a weakness of some kind.

SHMI: Gambling. Everything here revolves around betting on those awful races.

QUI-GON: Podracing... Greed can be a powerful ally...if it's used properly.

ANAKIN: I've built a racer! It's the fastest ever... There's a big race tomorrow, on Boonta Eve. You could enter my Pod. It's all but finished...

SHMI: Anakin, settle down. Watto won't let you...

ANAKIN: Watto doesn't know I've built it. *(to Qui-Gon)* You could make him think it was yours, and you could get him to let me pilot it for you.

QUI-GON looks to SHMI. She is upset.

SHMI: I don't want you to race, Annie... It's awful. I die every time Watto makes you do it.

ANAKIN: But Mom, I love it...and they need help... they're in trouble. The prize money would more than pay for the parts they need.

JAR JAR: Wesa ina pitty bad goo.

QUI-GON: Your mother's right. Is there anyone friendly to the Republic who might be able to help us?

SHMI shakes her head no.

ANAKIN: We have to help them, Mom...you said that the biggest problem in the universe is no one helps each other...
SHMI: Anakin, don't...

JAR JAR belches. There is silence for a moment as they eat.

PADMÉ: I'm sure Qui-Gon doesn't want to put your son in danger. We will find another way...
SHMI: No, Annie's right, there is no other way... I may not like it, but he can help you...he was meant to help you.
ANAKIN: Is that a yes? That is a yes!

The storm continues to rage outside the slave hovel.

EXT. MOS ESPA—JUNK DEALER PLAZA—DAY

The storm has passed. VENDORS and STREET PEOPLE clean up the mess and rebuild their food stalls. JAR JAR sits on a box in front of Watto's parts shop, watching all the activity with growing nervousness. ARTOO is standing next to him. PADMÉ stops QUI-GON as he is about to enter the shop.

PADMÉ: Are you sure about this? Trusting our fate to a boy we hardly know. The Queen will not approve.

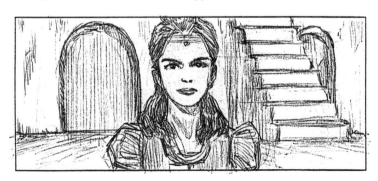

QUI-GON: The Queen does not need to know.
PADMÉ: Well, I don't approve.

QUI-GON turns and starts into the shop.

INT. WATTO'S JUNK SHOP—DAY

WATTO and ANAKIN are in the middle of an animated discussion in Huttese.

WATTO: Patta go bolla!
ANAKIN: No batta!
WATTO: Pedunky. Maa kee cheelya.
ANAKIN: Bayno, Bayno!

QUI-GON walks in, and WATTO and ANAKIN join him.

WATTO: The boy tells me you wanta sponsor him inda race. You can't afford parts. How can you do this? Not on Republic credits, I think. *(he laughs)*
QUI-GON: My ship will be the entry fee.

QUI-GON pulls a small object that looks like a watch out of his pocket, and a hologram of the Naboo spacecraft appears about a foot long in front of WATTO. He studies it.

WATTO: Not bad...not bad...a Nubian.
QUI-GON: It's in good order, except for the parts we need.
WATTO: ...but what would the boy ride? He smashed up my Pod in the last race. It will take some long time to fix it.

ANAKIN is embarrassed and steps forward.

ANAKIN: Ahhhh...it wasn't my fault really...Sebulba flashed me with his vent ports. I actually saved the Pod...mostly.
WATTO: *(laughing)* That you did. The boy is good, no doubts there.
QUI-GON: I have...acquired a Pod in a game of chance. "The fastest ever built."
WATTO: I hope you didn't kill anyone I know for it. *(laughs)* So, you supply the Pod and the entry fee; I supply the boy. We split the winnings fifty-fifty, I think.
QUI-GON: Fifty-fifty!?! If it's going to be fifty-fifty, I suggest you front the cash for the entry. If we win, you keep all the winnings, minus the cost of the parts I need... If we lose, you keep my ship.

WATTO thinks about this. ANAKIN tries not to be nervous.

QUI-GON: *(Cont'd)* Either way, you win.
WATTO: *(subtitled)* Deal! Yo bana pee ho-tah, meendee ya. *(Your friend is a foolish one, methinks.)*

EXT. NABOO SPACECRAFT—TATOOINE DESERT—DAY

OBI-WAN stands outside the Naboo spacecraft, speaking into his comlink. Qui-Gon is on the back porch of the hovel.

OBI-WAN: What if this plan fails, Master? We could be stuck here for a long time.

QUI-GON: *(V.O.)* A ship without a power supply will not get us anywhere, and there is something about this boy...

EXT. MOS ESPA—SLAVE QUARTERS—PORCH—DAY

QUI-GON puts the comlink away as SHMI comes onto the porch.
 PADMÉ, ANAKIN, JAR JAR, and ARTOO work on the engines of the Podracer in the courtyard below.

QUI-GON: You should be proud of your son. He gives without any thought of reward.

SHMI: He knows nothing of greed. He has...

 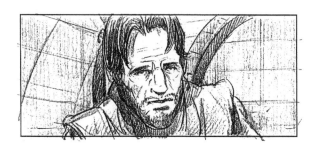

QUI-GON: He has special powers.

SHMI: Yes...

QUI-GON: He can see things before they happen. That's why he appears to have such quick reflexes. It is a Jedi trait.

SHMI: He deserves better than a slave's life.

QUI-GON: The Force is unusually strong with him, that much is clear. Who was his father?

SHMI: There was no father, that I know of... I carried him, I gave birth... I can't explain what happened. Can you help him?

QUI-GON: I'm afraid not. Had he been born in the Republic, we would have identified him early, and he would have become a Jedi, no doubt...he has the way. But it's too late for him now, he's too old.

EXT. MOS ESPA—SLAVE QUARTERS—BACK YARD—DAY

KITSTER (a young boy about Anakin's age), SEEK (a boy of ten), AMEE (a girl of six), and WALD (a Greedo Type, six years old) join ANAKIN, JAR JAR, ARTOO, and PADMÉ securing some wiring.

ANAKIN: Padmé and Jar Jar, this is my best friend Kitster, and Seek, Amee, and Wald.

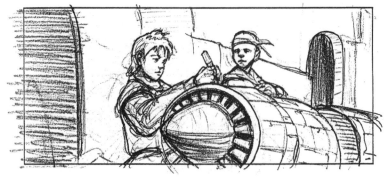

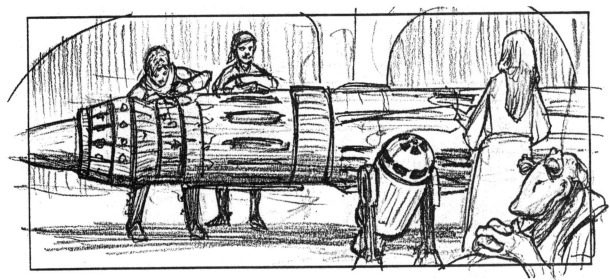

ALL whistle, hoot, and speak a greeting.

KITSTER: Wow, a real Astro Droid...how'd you get so lucky?
ANAKIN: That isn't the half of it. I'm entered in the Boonta Race tomorrow!
KITSTER: What? With this??
WALD: (subtitled) Annie, Jesko na joka. (You are such a joke, Annie.)
AMEE: You've been working on that thing for years. It's never going to run.
SEEK: Come on, let's go play ball. Keep it up, Annie, and you're gonna be bug squash.

SEEK, WALD, and AMEE take off, laughing. JAR JAR is fiddling with one of the energy binder plates.

ANAKIN: Hey! Jar Jar! Stay away from those energy binders…
JAR JAR: Who, mesa?
ANAKIN: If your hand gets caught in that beam, it will go numb for hours.

JAR JAR peeks at the energy plate; it makes a little electronic pop, zaps him in the mouth and he jumps back. JAR JAR tries to say something, but his mouth is numb and his words are all garbled.

JAR JAR: Ouch—dats muy bigo Oucho. *(Gibberish)*
KITSTER: But you don't even know if this thing will run.
ANAKIN: It will.

QUI-GON approaches the GROUP and gives ANAKIN a small battery. JAR JAR gets his hand caught in the afterburner and tries to tell Anakin, but can't get words out that make sense.

QUI-GON: I think it's time we found out. Use this power charge.
ANAKIN: Yes, sir!!

ANAKIN jumps into the little capsule behind the two giant engines. He puts the power pack into the dashboard. EVERYONE backs away, except for JAR JAR who calls for help. Finally PADMÉ frees him and the engines ignite with a ROAR. EVERYONE cheers.

EXT. MOS ESPA—SLAVE QUARTERS—PORCH—DAY

SHMI, watching from the porch, smiles sadly.

EXT. SLAVE QUARTERS—BALCONY—NIGHT

ANAKIN sits on the balcony rail of his hovel as QUI-GON tends to a cut. The BOY leans back to look at the vast blanket of stars in the sky.

QUI-GON: Sit still, Annie. Let me clean this cut.
ANAKIN: There are so many! Do they all have a system of planets?
QUI-GON: Most of them.
ANAKIN: Has anyone been to them all?
QUI-GON: *(laughs)* Not likely.
ANAKIN: I want to be the first one to see them all… Ouch!

QUI-GON wipes a patch of blood off ANAKIN'S arm.

QUI-GON: There, good as new…

SHMI yells from inside the hovel.

SHMI: *(O.S.)* Annie, bedtime!

QUI-GON scrapes ANAKIN's blood onto a comlink chip.

ANAKIN: What are you doing?

QUI-GON: Checking your blood for infections.

ANAKIN: I've never seen...

SHMI: *(O.S.)* Annie! I'm not going to tell you again!

QUI-GON: Go on, you have a big day tomorrow. *(beat)* Goodnight.

ANAKIN rolls his eyes and runs into the hovel. QUI-GON takes the blood-stained chip and inserts it into the comlink, then calls OBI-WAN.

QUI-GON: *(Cont'd)* Obi-Wan...

OBI-WAN: Yes, Master.

QUI-GON: Make an analysis of this blood sample I'm sending you.

OBI-WAN: Wait a minute...

QUI-GON: I need a midi-chlorian count.

OBI-WAN: All right. I've got it.

QUI-GON: What are your readings?

OBI-WAN: Something must be wrong with the transmission.

QUI-GON: Here's a signal check.

OBI-WAN: Strange. The transmission seems to be in good order, but the reading's off the chart...over twenty thousand.

QUI-GON: *(almost to himself)* That's it then.

OBI-WAN: Even Master Yoda doesn't have a midi-chlorian count that high!

QUI-GON: No Jedi has.

OBI-WAN: What does it mean?

QUI-GON: I'm not sure.

The JEDI KNIGHT looks up and sees SHMI in the doorway watching him. Embarrassed, she goes back into the kitchen while QUI-GON ponders the situation.

EXT. TATOOINE—DESERT MESA—NIGHT

The sinister-looking Sith spacecraft lands on top of a desert mesa at dusk, scattering a herd of banthas. DARTH MAUL walks to the edge of the mesa and studies the landscape with a pair of electrobinoculars. He picks out the lights of three different cities in the distance, then pushes buttons on his electronic armband.

Six football-sized PROBE DROIDS float out of the ship and head off in three different directions toward the cities.

DARTH MAUL stands on the mesa and watches them through his electrobinoculars.

EXT. MOS ESPA—SLAVE QUARTERS—PORCH—SUNRISE

Padmé exits the hovel.

EXT. MOS ESPA—SLAVE QUARTERS—BACK YARD—SUNRISE

As the twin suns rise, ARTOO is busy painting the racing Pod. ANAKIN is asleep. PADMÉ passes ARTOO.

PADMÉ: I hope you're about finished.

ARTOO whistles a positive reply. PADMÉ sees KITSTER riding toward them on an EOPIE, a strange camel-like creature. He is leading a sec- ond EOPIE behind him. PADMÉ goes over to ANAKIN. He looks very vulnerable as he sleeps. She watches him, then touches him on the cheek. ANAKIN wakes up, yawns, and looks at her, a little puzzled.

ANAKIN: You were in my dream...you were leading a huge army into battle.
PADMÉ: I hope not; I hate fighting. Your mother wants you to come in and clean up. We have to leave soon.

ANAKIN stands up and stretches just as KITSTER arrives.

ANAKIN: Hook 'em up, Kitster. *(to Padmé)* I won't be long. Where's Qui-Gon?
PADMÉ: He and Jar Jar left already. They're with Watto at the arena.

EXT. MOS ESPA—ARENA—MAIN HANGAR—DAY

RACE CREWS mill about outside the Main Hangar.

INT. MOS ESPA —ARENA—MAIN HANGAR—DAY

The hangar is a large building with a dozen or so Podracers being readied for the race. ALIEN CREWS and PILOTS rush about, making last minute fixes on their vehicles. WATTO, QUI-GON, and JAR JAR walk through the activity.

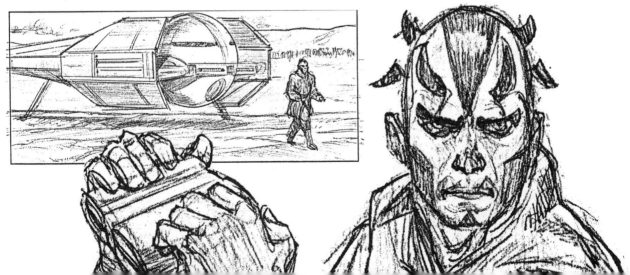

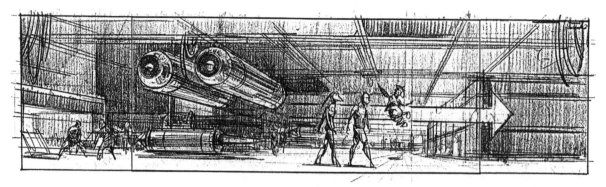

WATTO: ...I want to see your spaceship the moment the race is over.

QUI-GON: Patience, my blue friend. You'll have your winnings before the suns set, and we'll be far away from here.

WATTO: Not if your ship belongs to me, I think... I warn you, no funny business.

QUI-GON: You don't think Anakin will win?

WATTO stops before an orange racer. Sitting to one side, having his neck and shoulders massaged by TWIN YOBANAS, is SEBULBA.

WATTO: Don't get me wrongo. I have great faith in the boy. He's a credit to your race, but Sebulba there is going to win, I think.

QUI-GON: Why?

WATTO: He always wins. *(laughs)* I'm betting heavily on Sebulba.

QUI-GON: I'll take that bet.

WATTO: *(suddenly stops laughing)* What??!! What do you mean?

QUI-GON: I'll wager my new racing Pod against...say...the boy and his mother.

WATTO: A Pod for slaves. I don't think so...well, perhaps. Just one...the mother, maybe...the boy isn't for sale.

QUI-GON: The boy is small, he can't be worth much.

WATTO shakes his head.

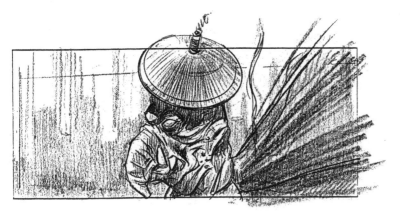

QUI-GON: *(Cont'd)* For the fastest Pod ever built?!

WATTO shakes his head again.

QUI-GON: *(Cont'd)* Both, or no bet.
WATTO: No Pod's worth two slaves...not by a long shot...one slave or nothing.
QUI-GON: The boy, then...

WATTO pulls out a small cube from his pocket.

WATTO: We'll let fate decide. Blue it's the boy, red his mother...

WATTO tosses the cube down. QUI-GON lifts his hand slightly; it turns blue. QUI-GON smiles. WATTO is angry.

WATTO: *(Cont'd)* You won the small toss, outlander, but you won't win the race, so...it makes little difference.

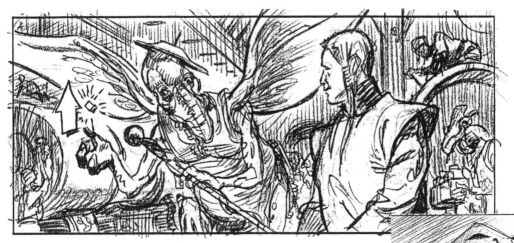

ANAKIN and PADMÉ enter the hangar on one of the EOPIES, pulling an engine. KITSTER, on the other EOPIE, is pulling another engine. With THREEPIO walking alongside, ARTOO trundles behind, pulling the Pod with SHMI sitting in it. WATTO passes ANAKIN as he leaves.

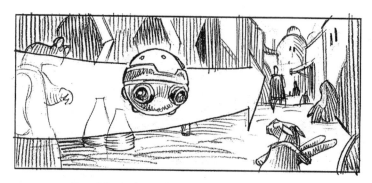

WATTO: *(Cont'd) (subtitled)* Bonapa keesa pateeso, o wanna meetee chobodd. *(Better stop your friend's betting, or I'll end up owning him, too.)*

WATTO walks off, laughing.

ANAKIN: What did he mean by that?
QUI-GON: I'll tell you later.

ARTOO beeps at THREEPIO.

THREEPIO: Oh my! Space travel sounds rather perilous.

ARTOO emits a series of beeps.

THREEPIO: I can assure you they will never get me onto one of those dreadful starships!
KITSTER: *(to Anakin)* This is so wizard! I'm sure you'll do it this time, Annie.
PADMÉ: Do what?
KITSTER: Finish the race, of course!
PADMÉ: You've never won a race?
ANAKIN: Well...not exactly...
PADMÉ: Not even finished?!

ANAKIN looks sheepish.

ANAKIN: ...but Kitster's right, I will this time.
QUI-GON: Of course you will.

EXT. MOS ESPA—STREET—DAY

One of Darth Maul's PROBE DROIDS slowly floats down the main street of Tatooine. It looks in shops and studies PEOPLE as it searches for OBI-WAN, QUI-GON, or the QUEEN.

EXT. MOS ESPA—DESERT RACE ARENA—DAY

An EXTREME HIGH WIDE ANGLE reveals a vast arena in the Tatooine desert. A large semi-circular amphitheater that holds at least a hundred thousand people dominates the landscape. Large viewing platforms loom over the racetrack.

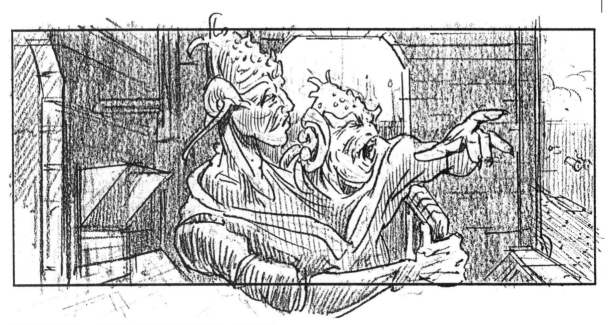

INT. MOS ESPA —ARENA ANNOUNCER'S BOX—DAY (FX)

A two-headed ANNOUNCER describes the scene.

FODE/BEED: A: Toogi! Toogi! *(Greetings)* Toong mee cha kulkah du Boonta magi, tah oos azalus ooval Poddraces. *(We have perfect weather today for the Boonta Classic. The most hazardous of all Podraces.)*
B: That's absolutely right. And a big turnout here, from all corners of the Outer Rim territories. I see the contestants are making their way out onto the starting grid.

EXT. MOS ESPA—DESERT RACE ARENA—DAY

On the left side of the tracks across from the grandstands, a line of Podracers emerges from the large hangar, surrounded by several CREW MEMBERS. Pods are pulled by a wide variety of CREATURES and are led by aliens carrying flags. The PILOTS stand facing the royal box.

FODE/BEED: *(O.S.)* A: La Yama beestoo *(Yes, there they are!)*
B: I see Ben Quadinaros from the Tund system.
A: ...eh Gasgano doowa newpa Ord Petrovia! *(And Gasgano in his new Ord Pedrovia.)*
B: Two time winner, Boles Roor...
A: Poo tula moosta, woe granee champio Sebulba du Pixelito! Spastyleeya bookie ookie!! *(On the front line the reigning champion, Sebulba from Pixelito. By far the favorite today.)*
B: And a late entry, Anakin Skywalker, a local boy.
A: Wampa peedunkee unko *(I hope he has better luck this time.)*
B: I see the flaggers are moving onto the track.

EXT. MOS ESPA—ARENA—GRANDSTAND—DAY

Colorful canopies shade some of the SPECTATORS. VENDORS sell bar-becued creature parts and colorful drinks.

EXT. MOS ESPA—ARENA—ROYAL BOX—DAY (FX)

All the PILOTS bow from the waist as JABBA THE HUTT enters the box and waves to the crowd.

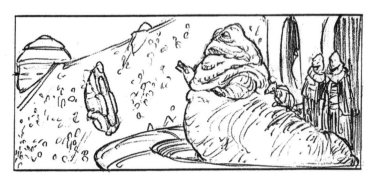

FODE/BEED: *(O.S.)* A: 0 grandio lust, Jabba Du Hutt, amu intoe tah parena. *(His honor, our glorious host, Jabba the Hutt has entered the arena.)*

The crowd ROARS. SEVERAL OTHER SLUG-LIKE HUTTS follow, along with humans and aliens. Several SLAVE GIRLS on a chain are led alongside JABBA.

JABBA: *(subtitled)* Chowbaso! Tam ka chee Boonta rulee ya, kee madda hodrudda du wundee. *(Welcome!)* Sebulba tuta Pixelito...

EXT. MOS ESPA—ARENA—STARTING GRID—DAY

SEBULBA, who is right next to ANAKIN, stands and waves to his fans. A small pep band plays as his fans wave and cheer.

 KITSTER attaches the giant engines to Anakin's Pod with a long cable. SHMI gives ANAKIN a big hug and kiss. She looks him right in the eye.

SHMI: Be safe.
ANAKIN: I will, Mom. I promise.

She leaves as ANAKIN checks the cable hitches.

JABBA: ...Mawhonic tuta Hok, Teemto Pagalies tuta Moonus Mandel, Anakin Skywalker tuta Tatooine....

The CROWD YELLS. ANAKIN waves to the crowd, as JABBA continues with his introductions. SEBULBA moves over to one of Anakin's engines. KITSTER and JAR JAR unhitch the EOPIES, and KITSTER leads them away. ARTOO beeps that everything is OK. JAR JAR pats ANAKIN on the back.

JAR JAR: Dis berry loony, Annie. May da guds be kind, mesa palo.

PADMÉ comes up and gives ANAKIN a little kiss on the cheek. SEBULBA bangs on a part protruding from Anakin's engine. He looks around to see if anyone has noticed.

PADMÉ: You carry all our hopes.
ANAKIN: I won't let you down.

PADMÉ moves away as SEBULBA edges his way next to ANAKIN and gives him a sinister grin.

SEBULBA: Bazda wahota, shag. Dobiellia Nok. Yoka to Bantha poodoo. *(You won't walk away from this one, slave scum! You're Bantha poodoo.)*
ANAKIN: *(subtitled)* Cha skrunee da pat, sleemo. *(Don't count on it, slime-ball.)*

ANAKIN looks the evil SEBULBA in the eye with a cold stare. QUI-GON approaches, and SEBULBA backs off toward his racer.

JABBA: *(subtitled)*…Kaa bazza kundee hodrudda! *(…Let the challenge begin!)*

The CROWD lets out a LOUD CHEER. QUI-GON helps ANAKIN into his Pod. The boy straps himself into the tiny racer.

QUI-GON: Are you all set, Annie? *(Anakin nods)* Remember, concentrate on the moment. Feel. Don't think. Trust your instincts. (he smiles) May the Force be with you.

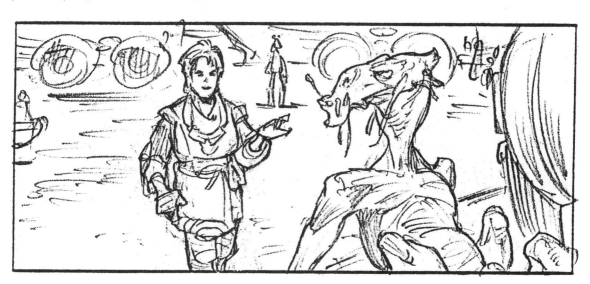

QUI-GON steps away as ANAKIN puts on his goggles. The PILOTS flip switches, and powerful energy binders shoot between the engines. ANAKIN flips a switch, and his engine starts. The incredible ROAR of high-powered engines igniting echoes throughout the arena. One driver, ODY MANDRELL, yells at a droid (DUM-4) to get away from the front of his engine. The crowd is tense.

EXT. MOS ESPA—ARENA —STARTING GRID—DAY

The giant power-house engines torque as the PILOTS gun them. The PILOTS flip switches, and powerful energy binders shoot between the engines. Aliens carrying large flags move off the track. JAR JAR covers his eyes.

JAR JAR: Mesa no watch. Dissen ganna be messy!
FODE/BEED: *(O.S.)* A: Ya pawa culka doe rundee! *(The power couplings are being activated.)*
B: Hey, it looks like they're clearing the grid.

EXT. MOS ESPA—ARENA —VIEWING PLATFORM—DAY

SHMI looks nervously to QUI-GON as he enters a viewing platform. PADMÉ and JAR JAR are already on board. The platform rises like an elevator.

SHMI: Is he nervous?
QUI-GON: He's fine.
PADMÉ: You Jedi are far too reckless. The Queen...
QUI-GON: The Queen trusts my judgment, young handmaiden. You should too.
PADMÉ: You assume too much.

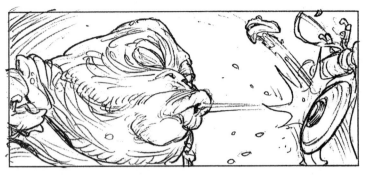

EXT. MOS ESPA—ARENA ANNOUNCER'S BOX—DAY (FX)

FODE/BEED: B: Start your engines!

The earth-pounding ROAR of the engines revving is deafening.

EXT. MOS ESPA —ARENA—ROYAL BOX—DAY (FX)

Jabba bites off the head of a frog and spits it at a gong, signaling the start of the race.

EXT. MOS ESPA—ARENA —STARTING GRID—DAY

On a bridge over the track, a great green light at the center flashes. The Podracers shoot forward with a high-pitched scream. ANAKIN's engine floods and coughs—then dies. All the other Podracers except one swerve around him and disappear down the track. The slave boy struggles to get his racer restarted. The two-headed announcer reports.

FODE/BEED: *(O.S.)* A: An dare ovv! *(And they're off!)*
B: Oh...wait. Little Skywalker has stalled.

PADMÉ and JAR JAR are very disappointed with ANAKIN. QUI-GON puts his arm around a worried looking SHMI to comfort her. Finally, Anakin's engines ignite. He zooms away after the receding pack of competitors, leaving one quadra-Pod racer still trying to get started. The two-headed ANNOUNCER describes the race as it progresses.

FODE/BEED: *(O.S.)* B: And there goes Skywalker... He'll be hard pressed to catch up with the leaders today.

EXT. MOS ESPA—RACETRACK—DAY (FX)

The Podracers fly across the desert. SEBULBA is running neck and neck with MAWHONIC. They round the first turn in the track, side by side. SEBULBA drives his Pod into his rival, forcing him into the wall of a large rock formation. MAWHONIC crashes in a spectacular display of fire and smoke.

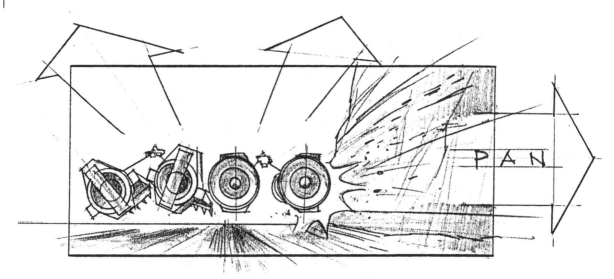

ANAKIN is much faster than the back-end stragglers and passes them easily.

One of the drivers, GASGANO, won't let ANAKIN by. ANAKIN tries to pass him on one side and is cut off. He then tries to pass him on the other side and is cut off. As they come up on a cliff drop-off, ANAKIN backs off, then guns it as GASGANO goes over the cliff. ANAKIN accelerates so fast that he sails right over the top of GASGANO and speeds away.

Four TUSKEN RAIDERS perched above the race course fire their rifles at the Pods racing in the canyon below them. One shot ricochets off the back of ANAKIN's Pod.

FODE/BEED: (O.S.) B: Looks like a few Tusken Raiders have camped out on the canyon dune turn.

EXT. MOS ESPA—ARENA—VIEWING PLATFORM—DAY

JABBA THE HUTT and the crowd watch the progress of the race on small, hand-held view screens. JAR JAR is looking over the shoulder of a strange alien named FANTA.

JAR JAR: Where's Skywalker?

FANTA moves the view screen out of Jar Jar's view. PADMÉ, SHMI, and QUI-GON watch another screen and look worried.

ARTOO, down in the pits with KITSTER, lets out a worried sigh. The driver of the quadra-Pod looks worried.

EXT. MOS ESPA—RACETRACK—DAY (FX)

ANAKIN is powering around corners and over hills and cliffs, passing other racers right and left. SEBULBA is in the lead. He is being challenged by another racer, XELBREE.

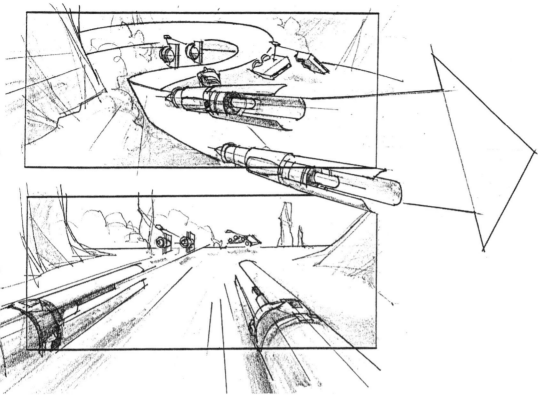

SEBULBA slows a little, and as XELBREE pulls alongside, he opens a side vent on the racer's engine and the exhaust starts to cut through the alien's engine.

The blast cuts along the engine until finally it EXPLODES. SEBULBA deftly veers away.

ANAKIN works his way through a dense mass of racers as they zoom over a dune sea, kicking up dust. His Pod shakes violently as he goes over a jump. One of the Podracers, ODY, catches one of his engines in the sand, and the whole thing EXPLODES.

EXT. MOS ESPA—ARENA—VIEWING PLATFORM—DAY

QUI-GON sits quietly, meditating. PADMÉ and SHMI search the landscape for any sign of the racers. JAR JAR is still annoying FANTA for information. The crowd SCREAMS. WATTO is laughing with his friends, confident in Anakin's defeat.

The quadra-Pod engines start just as the racers come around the corner. THE DRIVER, BEN QUADINAROS, puts it in gear, and the four engines go off in all directions, EXPLODING in a spectacular display. The Pod drops to the ground as SEBULBA enters the arena, closely followed by all the OTHER RACERS. KITSTER strains to see as ARTOO beeps excitedly. The announcer continues.

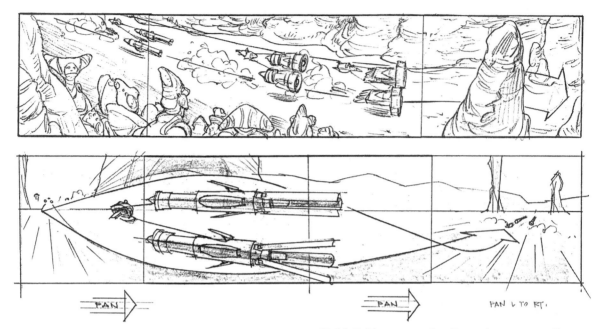

PAN PAN PAN L TO RT.

FODE/BEED: *(O.S.)* B: There goes Quadinaros' power couplings. A: Sebulba! Ka pa me cheespa wata! *(Here comes Sebulba in record time.)*

QUI-GON, PADMÉ, SHMI, and JAR JAR yell for joy as ANAKIN passes. JAR JAR is very nervous and pounds on the back of his alien neighbor, FANTA.

JAR JAR: What gooie-on?
FANTA: Bug off.

Lap two. SEBULBA and the pack race past the main arena. The crowd stands and YELLS as the Podracers scream off into the distance. QUI-GON and PADMÉ look worried.

JAR JAR: He musta crash-ud.
PADMÉ: Here he comes!

EXT. MOS ESPA—ARENA—PIT AREA—DAY

ARTOO lets out an excited whistle, as KITSTER yells.

THREEPIO: He has to complete two more circuits? Oh, dear!

EXT. MOS ESPA—RACETRACK—DAY (FX)

Sure enough, coming around the bend is ANAKIN, quickly gaining on the pack. The two-headed announcer describes the action. The crowd goes wild.

FODE/BEED: (O.S.) B: It looks like Skywalker is moving up through the field. He's in...
A: Steeth pa nagoola! *(Sixth place, not bad.)*

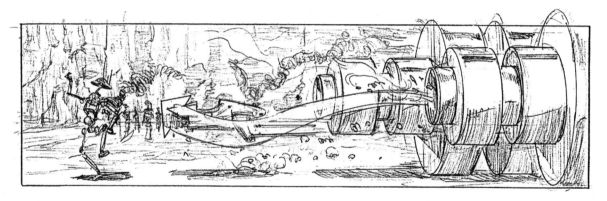

*ANAKIN continues to gain on the pack. Tension for SHMI and PADMÉ
is unbearable.*

*ODY stops in the pits. Droids work on his engines. DUM-4 stands
in front of the engine and is sucked in, causing the engine to die.
DUM-4 is spit out the back of the engine, very bent up. The engine
lets out one final wheeze, then EXPLODES in a puff of smoke.*

FODE/BEED: *(O.S.)* A: Ody Mandrell! Coona wa wunda dunko!
(Ody Mandrell into the pits for some attention.)
ODY: Droids!

*TERTER is getting close to SEBULBA, who purposely breaks a small
part off his Pod, sending it into Terter's engine, causing him to veer
into ANAKIN, and unhooks one of the main straps on Anakin's
engines that links the Pod to his engines.*

*ANAKIN struggles to keep control of the little Pod. It whips about
wildly. As the Pod swings near the broken engine strap, ANAKIN
grabs for it. Finally, he catches the strap and manages to rehook it
to the Pod.*

*SEBULBA cuts the engine of OBITOKI with his side exhaust, and
the racer crashes in a cloud of dust. A THIRD RACER, HABBA, flies
into the cloud of dust and crashes into OBITOKI. ANAKIN rounds a
corner and heads into the cloud of smoke. He hits a part of one of
the engines but regains control.*

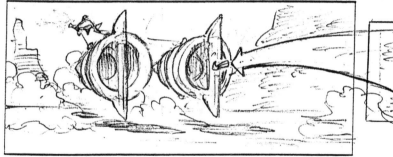

FODE/BEED: *(O.S.)* B: At the start of the third and final lap, Sebulba is in the lead, closely followed by Skywalker...

ANAKIN finally catches up with SEBULBA, and runs neck and neck over the rough terrain. JAR JAR, QUI-GON, SHMI, and PADMÉ all SCREAM as ANAKIN comes through the arena. The lights in the tower indicate that this is the third and last lap. WATTO begins to worry.

SEBULBA uses his side exhaust port to try to cut through Anakin's engines. ANAKIN manages to avoid having his engine disabled but is forced off course.

FODE/BEED: *(O.S.)* B: Skywalker is forced onto the service ramp!
A: Oh noah!

On a tight corner, ANAKIN dives to the inside and takes the lead.

FODE/BEED: *(O.S.)* B: Amazing...a controlled thrust and he's back on course! What a move.

SEBULBA is furious. He stays right on Anakin's tail, crowding him and pushing him through the turns.

SEBULBA pushes ANAKIN harder, and the young boy has a difficult time keeping control. One of the parts on Anakin's engines begins to shake loose. ANAKIN sees it and switches over to an auxiliary system. While he is trying to accomplish this maneuver, SEBULBA races past him.

ANAKIN tries to get around SEBULBA, to no avail. Every move ANAKIN makes, SEBULBA is able to block.

Finally, ANAKIN fakes a move to the inside as he usually does, then tries to go around SEBULBA on the outside. They race side by side down the final stretch of the track.

FODE/BEED: *(O.S.)* B: He's catching Sebulba.
A: Inkabunga! *(Incredible!)*

SEBULBA veers toward ANAKIN and bangs into his Pod. He crashes into ANAKIN over and over. The young boy struggles to maintain control as the steering rods on the two Pods become hooked together. SEBULA laughs at ANAKIN.

FODE/BEED: *(O.S.)* B: That little human being is out of his mind.
A: Punda tah punda! *(They're neck n' neck!)*
B: They're side by side!
A: Bongo du bongu! *(Shoulder to shoulder!)*

As they head for the final stretch, ANAKIN fights to unlock the steering rods by trying to pull away from SEBULBA. The strain on the steering rods is tremendous. Suddenly, ANAKIN's steering arm breaks, and his Pod starts spinning.

The release of tension sends SEBULBA into an ancient statue. One engine EXPLODES, then the other. SEBULBA skids through the fireballs, blackened, but unhurt. He slides to a smoking stop, gets out of his racer, and throws what's left of a shifter arm on the ground. Suddenly he realizes his pants are on fire, and he struggles to put them out.

ANAKIN flies through the EXPLOSION as the crowd stands, CHEER-ING. PADMÉ and JAR JAR jump up and down with excitement, PADMÉ screaming for joy. ARTOO and KITSTER whistle hysterically. QUI-GON and SHMI smile. ANAKIN races over the finish line, the winner.

INT. MOS ESPA—ARENA ANNOUNCER'S BOX—DAY (FX)

The two-headed announcer excitedly calls the finish.

FODE/BEED: B: It's Skywalker! The crowds are going nuts! Oh Ah Oh Ah *(rock head in tandem with partner)*

EXT. MOS ESPA—ARENA—DAY

As ANAKIN stops the Podracer, KITSTER runs up, and they embrace. Hundreds of SPECTATORS join them and put ANAKIN on their shoulders, marching off, CHEERING AND CHANTING. Darth Maul's PROBE DROIDS move through the crowd.

INT. MOS ESPA—ARENA—PRIVATE BOX—DAY

Several ALIENS leave Watto's box, laughing and counting their money. WATTO sees QUI-GON standing in the doorway.

WATTO: You! You swindled me! You knew the boy was going to win! Somehow you knew it! I lost everything.

WATTO flies up to QUI-GON and puts his face right up against QUI-GON's. QUI-GON simply smiles.

QUI-GON: Whenever you gamble, my friend, eventually you'll lose. Bring the parts to the main hangar. I'll come by your shop later so you can release the boy.
WATTO: You can't have him! It wasn't a fair bet!
QUI-GON: Would you like to discuss it with the Hutts...I'm sure they can settle this.
WATTO: No, no! I want no more of your tricks! Take him!

The SITH PROBE DROID watches this with great interest.

EXT. MOS ESPA—ARENA—MAIN HANGAR—DAY

The Main Hangar is almost deserted as RACERS depart.

INT. MOS ESPA—ARENA—MAIN HANGAR—DAY

JAR JAR gives ANAKIN a great hug, then PADMÉ gives him a hug, then SHMI.

ANAKIN: Ah, gee...enough of this...
SHMI: It's so wonderful, Annie. You have brought hope to those who have none. I'm so very proud of you...
PADMÉ: We owe you everything.

ANAKIN: Just feeling this good was worth it.

In the background, QUI-GON has harnessed the EOPIES to containers full of parts.

QUI-GON: Padmé, Jar Jar, let's go, we've got to get these parts back to the ship.

The GROUP walks over to QUI-GON and the EOPIES.

 PADMÉ climbs on behind QUI-GON. JAR JAR swings up onto the second EOPIE, only to slowly slide off the other side. ARTOO whistles. ANAKIN and SHMI wave as they ride off.

QUI-GON: (Cont'd) I'll return the eopies by midday.

EXT. TATOOINE—DESERT—NABOO SPACECRAFT—DAY

ARTOO cruises ahead of QUI-GON and PADMÉ, who are riding one of the EOPIES; JAR JAR rides the other. They stop in front of the sleek Naboo spacecraft. OBI-WAN comes out of the ship and joins them.

QUI-GON: Start getting this hyperdrive generator installed. I'm going back...some unfinished business. I won't be long.
OBI-WAN: Why do I sense we've picked up another pathetic life form...?
QUI-GON: It's the boy who's responsible for getting us those parts.

On a far hill overlooking the Naboo spacecraft, the SITH PROBE DROID turns and speeds away.

EXT. TATOOINE—STREET—SLAVE QUARTERS—DAY

ANAKIN and A GREEDO are rolling around on the ground, fighting. About A DOZEN OR SO KIDS are standing around them, yelling. Suddenly, a long shadow is cast over the TWO BOYS; they stop fighting and look up. QUI-GON is towering over them. KITSTER is with him.

QUI-GON: What's this?
ANAKIN: He said I cheated.
QUI-GON: Did you?
ANAKIN: No!
QUI-GON: Do you still think he cheated?
GREEDO: Yes.
QUI-GON: Well, Annie. You know the truth...You will have to tolerate his opinion, fighting won't change it.

QUI-GON moves off down the street. Anakin follows. The GREEDO wanders over to WALD who has been watching the goings-on.

WALD: Keep this up, Greedo, and you're gonna come to a bad end.

Farther down the street QUI-GON and ANAKIN head toward Anakin's hovel. QUI-GON takes a handful of credits from beneath his poncho and hands them to the boy.

QUI-GON: These are yours. We sold the Pod.
ANAKIN: *(suddenly beaming)* Yes!

INT. ANAKIN'S HOVEL—MAIN ROOM—DAY

SHMI is cleaning up as ANAKIN bursts through the door, followed by QUI-GON.

ANAKIN: Mom, he sold the Pod. Look at all the money we have!

ANAKIN pulls a bag of coins out of his pocket.

SHMI: Oh, my goodness. That's wonderful.
QUI-GON: And Anakin has been freed.
ANAKIN: What?!?
QUI-GON: You're no longer a slave.

ANAKIN jumps for joy! SHMI is stunned.

ANAKIN: Did you hear that, Mom? *(to Qui-Gon)* Was that part of the prize, or what?
QUI-GON: Let's just say Watto has learned an important lesson about gambling.
SHMI: Now you can make your dreams come true, Annie. You're free! *(turns to Qui-Gon)* Will you take him with you? Is he to become a Jedi?
QUI-GON: Our meeting was not a coincidence. Nothing happens by accident. You are strong with the Force, but you may not be accepted by the Council.
ANAKIN: A Jedi! Mighty blasters, you mean I get to go with you in your starship and everything?!

QUI-GON kneels down to the boy.

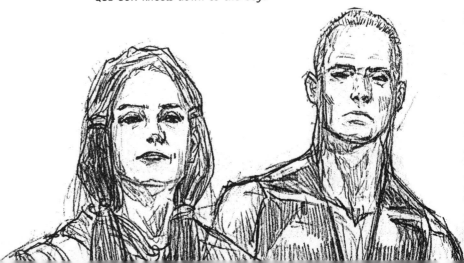

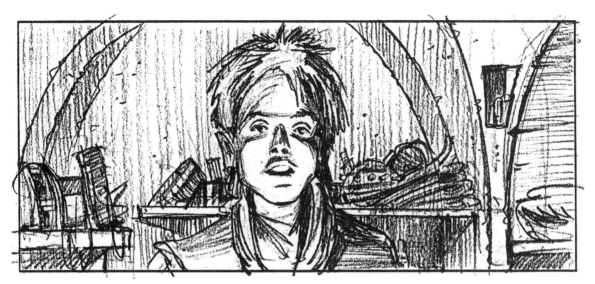

QUI-GON: Anakin, training to be a Jedi will not be an easy chal-
lenge. And if you succeed, it will be a hard life.
ANAKIN: But it's what I want. What I've always dreamed about.
Can I go, Mom?!
QUI-GON: This path has been placed before you, Annie; the
choice to take it is yours alone.

ANAKIN thinks, looks to his mother, then to QUI-GON.

ANAKIN: I want to go.
QUI-GON: Then, pack your things. We haven't much time.
ANAKIN: Yippee!!

*ANAKIN hugs his mom and starts for the other room, then stops.
SHMI and QUI-GON give each other a knowing look. ANAKIN has
realized something.*

ANAKIN; *(Cont'd)* What about Mom? Is she free too? You're com-
ing, aren't you, Mom?
QUI-GON: I tried to free your mother, Annie, but Watto wouldn't
have it.
ANAKIN: But the money from selling...
QUI-GON: It's not nearly enough.

*SHMI comes over to her son and sits next to him. Taking both of his
hands in hers, she draws him close.*

SHMI: Son, my place is here. My future is here. It is time for you
to let go...to let go of me. I cannot go with you.
ANAKIN: I want to stay with you. I don't want things to change.
SHMI: You can't stop change any more than you can stop the
suns from setting. Listen to your feelings; Annie, you know what's
right.

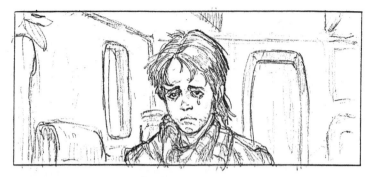

ANAKIN takes a deep breath, drops his head. QUI-GON and SHMI exchange a look of concern. When ANAKIN raises up, there are tears in his eyes.

ANAKIN: I'm going to miss you so much, Mom...
SHMI: I love you, Annie...now hurry.

ANAKIN and SHMI hug. ANAKIN runs into the other room.

SHMI: *(Cont'd)* Thank you.
QUI-GON: I will watch after him. You have my word. Will you be all right?
SHMI: He was in my life for such a short time.

INT. ANAKIN'S HOVEL—SECOND ROOM—DAY

ANAKIN has thrown the last of his things in a small backpack. As he leaves, he stops and pushes the button that wakes his droid up. THREEPIO stares at him blankly.

ANAKIN: Well, Threepio, I'm free...and I'm going away...in a starship...
THREEPIO: Master Annie, you are my maker, and I wish you well. Although I'd like it better if I were a little less naked.
ANAKIN: I'm sorry I wasn't able to finish you, Threepio...give you coverings and all... I'm going to miss working on you. You've been a great pal. I'll make sure Mom doesn't sell you or anything. Bye.

THREEPIO stares at ANAKIN as he rushes out of the room.

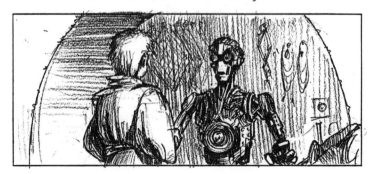

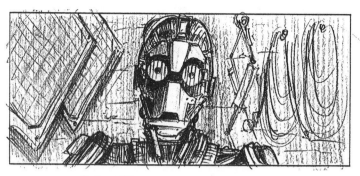

THREEPIO: Sell me?!?

EXT. MOS ESPA—STREET—SLAVE QUARTERS—DAY

KITSTER runs up to ANAKIN as he and QUI-GON exit Anakin's hovel. SHMI stands in the doorway. ANAKIN pulls a handful of coins out of his pocket and gives them to KITSTER.

KITSTER: There are so many of us who want you to stay, Annie... You're a hero.
ANAKIN: I...*(looks to SHMI)* I...have to go.

QUI-GON has moved a short way down the street.

KITSTER: Well.
ANAKIN: Well.
KITSTER: Thanks for every moment you've been here. You're my best friend.
ANAKIN: I won't forget...

ANAKIN hugs KITSTER and runs toward QUI-GON, then stops to look back at his mother standing in the doorway. He turns back to QUI-GON, then turns and runs back to his mother.

ANAKIN: *(starting to cry)* I can't do it, Mom. I just can't.

SHMI hugs ANAKIN. QUI-GON watches from the distance. She kneels down and looks him in the face.

SHMI: Annie, remember when you climbed the great dune in order to chase the Banthas away so they wouldn't be shot... Remember how you collapsed several times, exhausted thinking you couldn't do it?

ANAKIN shakes his head.

SHMI: *(Cont'd)* This is one of those times when you have to do something you don't think you can do. I know how strong you are, Annie. I know you can do this...
ANAKIN: Will I ever see you again??
SHMI: What does your heart tell you?

ANAKIN: I hope so...yes...I guess.
SHMI: Then we will see each other again.
ANAKIN: I...will become a Jedi and I will come back and free you, Mom... I promise.
SHMI: No matter where you are, my love will be with you. Now be brave, and don't look back...don't look back.
ANAKIN: I love you so much.

SHMI hugs ANAKIN, then turns him around so he is facing QUI-GON, and off he marches, like the brave little trooper that he is. He marches right past QUI-GON, staring straight ahead, tears in his eyes, determined not to look back.

EXT. TATOOINE—DESERT MESA—DAY

The PROBE DROID beeps and whistles to DARTH MAUL. The SITH LORD gets on a speeder bike and follows the PROBE DROID into Mos Espa.

EXT. MOS ESPA—STREET—FRUIT STAND—DAY

ANAKIN and QUI-GON exit WATTO'S and stop before JIRA's fruit stand. ANAKIN hands JIRA some coins.

ANAKIN: I've been freed, and I'm going away. Buy yourself a cooling unit with this... Otherwise I'll worry about you.

JIRA is astonished. She stares, not knowing what to say.

JIRA: Can I give you a hug?
ANAKIN: Sure.

She gives him a hug.

JIRA: I'll miss you, Annie...there isn't a kinder boy in the galaxy. You be careful...

ANAKIN runs to join QUI-GON, who has already started down the street. As they walk along together, QUI-GON notices something out of the corner of his eye.

 Suddenly, without breaking his stride, he ignites his laser sword,

swings around, and lunges forward and cuts a lurking PROBE DROID in half. QUI-GON inspects the sparking and fizzing DROID.

ANAKIN: What is it?

QUI-GON: Probe droid. Very unusual...not like anything I've seen before. Come on.

QUI-GON and ANAKIN start running.

EXT. TATOOINE—DESERT—NABOO SPACECRAFT—DAY

QUI-GON and ANAKIN run toward the Naboo spacecraft. ANAKIN is having a hard time keeping up.

ANAKIN: Master Qui-Gon, sir, wait!

QUI-GON turns to answer and sees a DARK-CLOAKED FIGURE bearing down on a speeder bike.

QUI-GON: Anakin, drop!

ANAKIN drops to the ground just as DARTH MAUL sweeps over him. DARTH MAUL jumps off his speeder bike, and before he has hit the ground, the Sith Lord has swung a death blow with his laser sword that is barely blocked by QUI-GON.

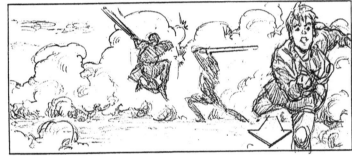

ANAKIN picks himself up. The two galactic warriors, Sith and Jedi, are bashing each other with incredible blows. They move in a continual cloud of dust, smashing everything around them. This is a fierce fight. ANAKIN gets up, bewildered by the confrontation.

QUI-GON: (Cont'd) Annie, get to the ship! Take off! Go! Go!

QUI-GON struggles to fend off the relentless onslaught as ANAKIN races to the ship.

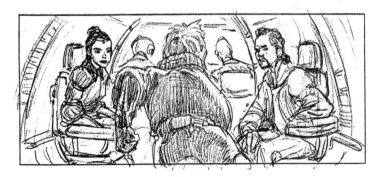

INT. NABOO SPACECRAFT—HALLWAY

ANAKIN runs into the main hallway of the spaceship, where PADMÉ and CAPTAIN PANAKA are working.

ANAKIN: Qui-Gon's in trouble. He says to take off...now!!
CAPT. PANAKA: Who are you?
PADMÉ: He's a friend.

INT. NABOO SPACECRAFT—COCKPIT

CAPTAIN PANAKA, ANAKIN, and PADMÉ rush into the cockpit where OBI-WAN and RIC OLIÉ are checking the hyperdrive.

CAPT. PANAKA: Qui-Gon is in trouble, he says to take off!
PILOT: I don't see anything.
OBI-WAN: Over there! Fly low!

In the distance is a small cloud of dust.

EXT. TATOOINE—DESERT—NABOO SPACECRAFT—DAY

QUI-GON and DARTH MAUL continue their sword battle. Leaping over one another in an incredible display of acrobatics, the two warriors hear the ship fly over them a few feet off the ground. QUI-GON almost disappears for a moment.

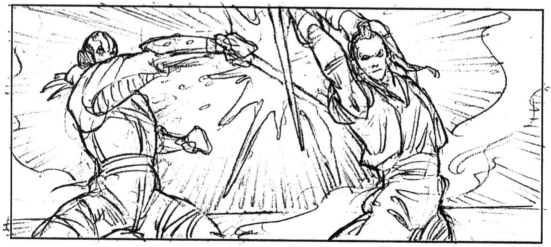

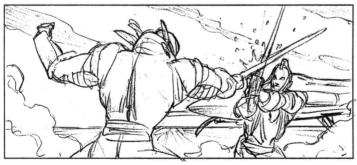

Before DARTH MAUL knows what's happening, QUI-GON is on the spacecraft's ramp.

EXT. TATOOINE—NABOO SPACECRAFT RAMP—DAY

The SITH LORD immediately jumps onto the ramp after QUI-GON, but barely makes it. His heels hang over the edge of a forty-foot drop. QUI-GON swings his laser sword with all his might and knocks DARTH MAUL off the ramp and onto the desert floor. The ramp closes, and the Naboo craft rockets away, leaving the Sith Lord standing alone.

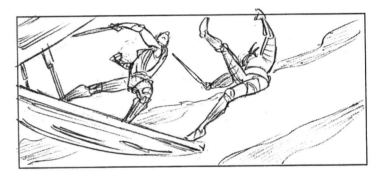

EXT. SPACE—NABOO SPACECRAFT (FX)

The sleek spacecraft rockets away from the planet Tatooine.

INT. NABOO SPACECRAFT—HALLWAY

ANAKIN and OBI-WAN rush into the hallway to find QUI-GON collapsed on the floor opposite the entry. ARTOO is looking over him. The JEDI is breathing hard, wet with sweat and covered in dirt.

ANAKIN: Are you all right?
QUI-GON: I think so...that was a surprise I won't soon forget.
OBI-WAN: What was it?
QUI-GON: I don't know...but he was well trained in the Jedi arts. My guess is he was after the Queen...
ANAKIN: Do you think he'll follow us?
QUI-GON: We'll be safe enough once we're in hyperspace, but I have no doubt he knows our destination.
ANAKIN: What are we going to do about it?

OBI-WAN gives ANAKIN a "who are you?" look. ANAKIN returns an innocent stare.

QUI-GON: We will be patient. Anakin Skywalker, meet Obi-Wan Kenobi.
ANAKIN: Pleased to meet you. Wow! You're a Jedi too?

OBI-WAN gives the boy a skeptical look.

INT. COCKPIT—SPACE

RIC OLIÉ pulls back on the hyperdrive. OBI-WAN, QUI-GON, and ANAKIN watch.

QUI-GON: Let's hope this hyperdrive works and Watto didn't get the last laugh.

The stars streak outside the cockpit window.

EXT. SPACE—NABOO SPACECRAFT (FX)

The ship streaks into hyperspace.

EXT. THEED—STREET—NIGHT (FX)

SEVERAL FEDERATION DROIDS patrol a deserted city street. The Palace can be seen in the distance.

INT. NABOO PALACE—THRONE ROOM—THEED—NIGHT

NUTE sits in a strange, mechanical walking chair, which approaches SIO BIBBLE and SEVERAL OTHER NABOO OFFICIALS. RUNE follows a few paces behind. DROID GUARDS surround SIO BIBBLE and THE OTHERS as FOUR COUNCIL MEMBERS watch.

NUTE: When are you going to give up this pointless strike? Your Queen is lost, your people are starving, and you, Governor, are going to die, much sooner than your people, I'm afraid. Take him away!

BIBBLE: This invasion will gain you nothing. We're a democracy. The people have decided...They will not live under your tyranny.

BIBBLE is taken away as OOM-9 approaches NUTE.

OOM-9: My troops are in position to begin searching the swamps for these rumored underwater villages...they will not stay hidden for long.

INT. NABOO SPACECRAFT—MAIN AREA

The ship is asleep. The lights are dim as PADMÉ walks into the main room. She goes to a monitor and watches the BIBBLE plea recording. JAR JAR is stretched out on the floor, snoring. ARTOO is to one side, cooing as he rests.

PADMÉ appears tired. She senses someone watching her and turns around with a start. She sees ANAKIN sitting in the corner, shivering and looking very dejected. She goes over to him. He looks up at her with tears in his eyes. He is holding his arms to keep himself warm.

PADMÉ: Are you all right?
ANAKIN: It's very cold.

PADMÉ gives him her over-jacket.

PADMÉ: You're from a warm planet, Annie. Too warm for my taste. Space is cold.
ANAKIN: You seem sad.
PADMÉ: The Queen is...worried. Her people are suffering...dying. She must convince the Senate to intervene, or...I'm not sure what will happen.
ANAKIN: I'm...I'm not sure what's going to happen to me. I dunno if I'll ever see you again... *(he pulls something from his pocket)* I made this for you. So you'd remember me. I carved it out of a japor snippet... It will bring you good fortune.

ANAKIN hands a wooden pendant to PADMÉ. She inspects it, then puts it around her neck.

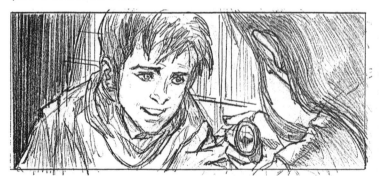

PADMÉ: It's beautiful, but I don't need this to remember you. Many things will change when we reach the capital, Annie. My caring for you will always remain.
ANAKIN: I care for you too. Only I...miss...

ANAKIN is disturbed about something. Tears are in his eyes.

PADMÉ: ...You miss your mother.

ANAKIN looks at her, unable to speak. She hugs him.

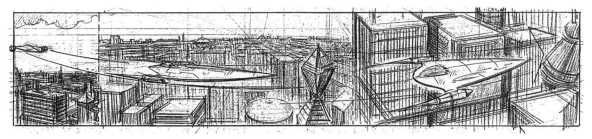

EXT. SPACE—PLANET CORUSCANT (FX)

MOVE with the ship as it heads toward Coruscant.

EXT. CORUSCANT—CITYSCAPE—NABOO SPACECRAFT—DAY (FX)

The spacecraft flies over the endless cityscape of Coruscant, the capital of the galaxy.

INT. NABOO SPACECRAFT—COCKPIT

ANAKIN looks out the cockpit window in awe.

RIC OLIÉ: Coruscant...the capital of the Republic...the entire planet is one big city.
ANAKIN: Wow! It's so huge!

EXT. NABOO SPACECRAFT—DAY (FX)

The ship flies through the cityscape of Coruscant.

EXT. CORUSCANT—SENATE LANDING PLATFORM—DAY

Supreme Chancellor VALORUM, SEVERAL GUARDS, and SENATOR PALPATINE stand on a landing platform.
 The sleek Naboo spacecraft lands on the platform high above the street level of the galactic capital. The ramp lowers. OBI-WAN, QUI-GON, JAR JAR, and ANAKIN descend the ramp first and bow before PALPATINE and VALORUM.
 CAPTAIN PANAKA, TWO GUARDS, QUEEN AMIDALA, then PADMÉ, RABÉ, EIRTAÉ, and MORE GUARDS descend the ramp. QUEEN AMIDALA stops before the group.

ANAKIN and JAR JAR stand to one side, looking at the huge city. PADMÉ smiles at ANAKIN. PALPATINE bows before the Queen.

PALPATINE: It is a great gift to see you alive, Your Majesty. May I present Supreme Chancellor Valorum.

VALORUM: Welcome, Your Highness. It is an honor to finally meet you in person. I must relay to you how distressed everyone is over the current situation. I've called for a special session of the Senate to hear your position.

AMIDALA: I am grateful for your concern, Chancellor.

PALPATINE starts to lead QUEEN AMIDALA and her RETINUE off the platform toward a waiting air taxi.

PALPATINE: There is a question of procedure, but I feel confident we can overcome it...

JAR JAR and ANAKIN start to follow, then stop, noticing that OBI-WAN and QUI-GON are staying with the SUPREME CHANCELLOR. QUEEN AMIDALA waves to the duo to follow her. ANAKIN looks back to QUI-GON, and he nods to go ahead.
ANAKIN and JAR JAR join the QUEEN, PALPATINE, PADMÉ, RABÉ, and EIRTAÉ in the taxi. PALPATINE gives the Gungan and the boy in the back of the taxi a skeptical look. JAR JAR leans over to ANAKIN.

JAR JAR: Da Queens-a bein grossly nice, mesa tinks. *(he looks around)* Pitty hot!

VALORUM and the JEDI watch the taxi move off into the city.

QUI-GON: I must speak with the Jedi Council immediately, Your Honor. The situation has become more complicated.

INT. PALPATINE'S QUARTERS—ANTEROOM—DAY

QUEEN AMIDALA is sitting listening to PALPATINE. EIRTAÉ and RABÉ stand behind the QUEEN; PADMÉ is nowhere to be seen. ANAKIN and JAR JAR are waiting in an adjoining room. They can see the Queen but cannot hear what is being said.

JAR JAR: Dissen all pitty odd to my.
ANAKIN: Don't look at me. I don't know what's going on.

CAPTAIN PANAKA enters, then goes into the room with QUEEN AMIDALA.

INT. PALPATINE'S QUARTERS—LIVING AREA—DAY

PALPATINE is pacing as CAPTAIN PANAKA enters. EIRTAÉ and RABÉ stand to one side.

PALPATINE: ...the Republic is not what it once was. The Senate is full of greedy, squabbling delegates who are only looking out for

themselves and their home systems. There is no interest in the common good...no civility, only politics...it's disgusting. I must be frank, Your Majesty, there is little chance the Senate will act on the invasion.

AMIDALA: Chancellor Valorum seems to think there is hope.

PALPATINE: If I may say so, Your Majesty, the Chancellor has little real power...he is mired down by baseless accusations of corruption. A manufactured scandal surrounds him. The bureaucrats are in charge now.

AMIDALA: What options do we have?

PALPATINE: Our best choice would be to push for the election of a stronger Supreme Chancellor. One who will take control of the bureaucrats, enforce the laws, and give us justice. You could call for a vote of no confidence in Chancellor Valorum.

AMIDALA: He has been our strongest supporter. Is there any other way?

PALPATINE: Our only other choice would be to submit a plea to the courts...

AMIDALA: There's no time for that. The courts take even longer to decide things than the Senate. Our people are dying, Senator...more and more each day. We must do something quickly to stop the Federation.

PALPATINE: To be realistic, Your Highness, I'd say we're going to have to accept Federation control for the time being.

AMIDALA: That is something I cannot do.

EXT. TEMPLE OF THE JEDI—DAY (FX)

A unique building with its tall spires stands out against the Coruscant skyline. A small transport passes by the vast temple.

INT. TEMPLE OF THE JEDI—COUNCIL CHAMBERS—DAY

QUI-GON stands in a tall stately room. Twelve JEDI sit in a semi-circle. OBI-WAN stands behind QUI-GON in the center of the room.

 The Senior Jedi is MACE WINDU. To his left is an alien Jedi named KI-ADI-MUNDI, and to his right, the Jedi Master, YODA.

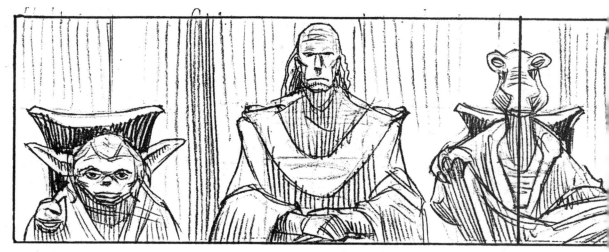

QUI-GON: ...my only conclusion can be that it was a Sith Lord.
MACE WINDU: A Sith Lord?!?
KI-ADI: Impossible! The Sith have been extinct for a millennium.
YODA: The very Republic is threatened, if involved the Sith are.
MACE WINDU: I do not believe they could have returned without us knowing.
YODA: Hard to see, the dark side is. Discover who this assassin is, we must.
KI-ADI: I sense he will reveal himself again.
MACE WINDU: This attack was with purpose, that is clear, and I agree the Queen is his target.
YODA: With this Naboo queen you must stay, Qui-Gon. Protect her.
MACE WINDU: We will use all our resources here to unravel this mystery and discover the identity of your attacker... May the Force be with you.
YODA: May the Force be with you.

OBI-WAN turns to leave, but QUI-GON continues to face the Council.

YODA: *(Cont'd)* Master Qui-Gon, more to say have you?
QUI-GON: With your permission, my Master. I have encountered a vergence in the Force.
YODA: A vergence, you say?
MACE WINDU: Located around a person?
QUI-GON: A boy...his cells have the highest concentration of midi-chlorians I have seen in a life form. It is possible he was conceived by the midi-chlorians.
MACE WINDU: You're referring to the prophesy of the one who will bring balance to the Force...you believe it's this boy??
QUI-GON: I don't presume...
YODA: But you do! Revealed your opinion is.
QUI-GON: I request the boy be tested.

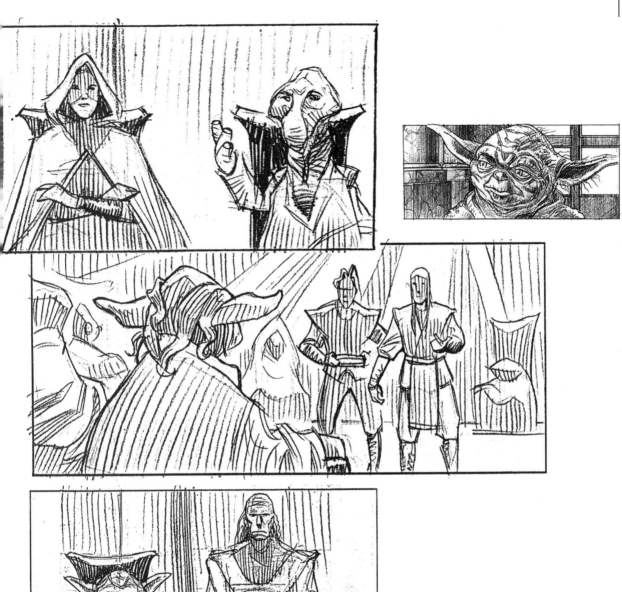

The JEDI all look to one another. They nod and turn back to OBI-WAN and QUI-GON.

YODA: Trained as a Jedi, you request for him?

QUI-GON: Finding him was the will of the Force...I have no doubt of that. There is too much happening here...

MACE WINDU: Bring him before us, then.

YODA: Tested he will be.

INT. QUEEN'S QUARTERS—CORUSCANT—DAY

Anakin, tentative, walks down one of the long hallways in Senator Palpatine's quarters. He stops before a door that is flanked by TWO GUARDS.

GUARD: May I help you, son?
ANAKIN: I'm...I'm looking for the handmaiden, Padmé.

The GUARD speaks into his comlink as ANAKIN looks around a bit nervously.

GUARD: The boy is here to see Padmé.
RABÉ: Send him in.

The doors open, and ANAKIN enters the Queen's quarters.
 RABÉ greets ANAKIN as TWO OTHER HANDMAIDENS come and go into the next room.

ANAKIN: I'd like to speak with Padmé, if I could.
RABÉ: I'm sorry, Annie. Padmé is not here right now.

The Queen speaks out in the next room.

AMIDALA: (O.S.) Who is it?
RABÉ: Anakin Skywalker, to see Padmé, Your Highness.

The QUEEN moves into the doorway and studies ANAKIN. ANAKIN bows and looks down, then takes a peek at her.

AMIDALA: I've sent Padmé on an errand.
ANAKIN: I'm going to the Jedi temple to start my training, I hope.

The QUEEN just stares at him.

ANAKIN: (*Cont'd*) I may not see her again...and...I just wanted to say goodbye.
AMIDALA: We will tell her for you. We're sure her heart goes with you.

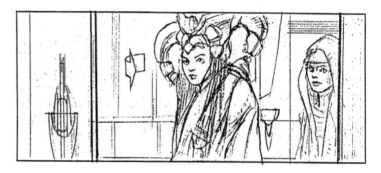

ANAKIN bows again.

ANAKIN: Thank you, Your Highness. I'm sorry to have disturbed you.

The QUEEN disappears behind the doorway, and ANAKIN exits.

EXT. CORUSCANT—GALACTIC SENATE BUILDING—DAY (FX)

A large, distinctive looking domed building stands out amid the cityscape of Coruscant.

INT. MAIN ROTUNDA—GALACTIC SENATE—DAY

The Senate chambers are huge. Thousands of SENATORS and their AIDES sit in the circular assembly area. CHANCELLOR VALORUM sits in an elevated area in the center. Hundreds of AIDES and DROIDS hurry about. SENATOR PALPATINE, QUEEN AMIDALA, EIRTAÉ, RABÉ, and CAPTAIN PANAKA sit in the Naboo congressional box, which is actually a floating platform. PALPATINE leans over to the QUEEN.

PALPATINE: If the Federation moves to defer the motion... Your Majesty, I beg of you to ask for a resolution to end this congressional session.

AMIDALA: I wish I had your confidence in this, Senator.

PALPATINE: You must force a new election for Supreme Chancellor... I promise you there are many who will support us...it is our best chance... Your Majesty, our only, chance.

AMIDALA: You truly believe Chancellor Valorum will not bring our motion to a vote?

PALPATINE: He is distracted...he is afraid. He will be of no help.

VALORUM: The Chair recognizes the Senator from the sovereign system of Naboo.

The Naboo congressional box floats into the center.

PALPATINE: Supreme Chancellor, delegates of the Senate. A tragedy has occurred on our peaceful system of Naboo. We have

become caught up in a dispute you're all well aware of, which began right here with the taxation of trade routes, and has now engulfed our entire planet in the oppression of the Trade Federation.

A second box rushes into the center of the Senate. It is filled with Federation trade barons led by LOTT DOD, the Senator for the Federation.

LOTT DOD: This is outrageous! I object to the Senator's statements!

VALORUM: The Chair does not recognize the Senator from the Trade Federation at this time. Please return to your station.

LOTT DOD reluctantly moves back to his place.

PALPATINE: To state our allegations, I present Queen Amidala, the recently elected ruler of the Naboo, to speak on our behalf.

QUEEN AMIDALA stands and addresses the assembly. There is some applause.

AMIDALA: Honorable representatives of the Republic, distinguished delegates, and Your Honor Supreme Chancellor Valorum, I come to you under the gravest of circumstances. The Naboo system has been invaded by force. Invaded...against all the laws of the Republic by the Droid Armies of the Trade...

LOTT DOD: I object! There is no proof. This is incredible. We recommend a commission be sent to Naboo to ascertain the truth.

VALORUM: Overruled.

LOTT DOD: Your Honor, you cannot allow us to be condemned

without reasonable observation. It's against all the rules of procedure.

A third box representing Malastare moves into the center of the room. AKS MOE, the Ambassador, addresses the convention.

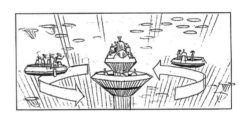

AKS MOE: The Congress of Malastare concurs with the honorable delegate from the Trade Federation. A commission must be appointed...that is the law.
VALORUM: The point...

VALORUM confers with several of his AIDES and VICE CHAIRMAN MAS AMEDDA. PALPATINE whispers something to the QUEEN.

PALPATINE: Enter the bureaucrats, the true rulers of the Republic, and on the payroll of the Trade Federation, I might add. This is where Chancellor Valorum's strength will disappear.
VALORUM: The point is conceded...Section 523A takes precedence here. Queen Amidala of the Naboo, will you defer your motion to allow a commission to explore the validity of your accusations?

QUEEN AMIDALA is angry but remains composed.

AMIDALA: *(angrily)* I will not defer...I have come before you to resolve this attack on our sovereignty now. I was not elected to watch my people suffer and die while you discuss this invasion in a committee. If this body is not capable of action, I suggest new leadership is needed. I move for a "vote of no confidence"...in Chancellor Valorum's leadership.
VALORUM: What?...No!

This causes a great stir in the assembly. A loud murmur crescendos into a roar of approval and jeers. CHANCELLOR VALORUM is stunned and stands speechless. His Vice Chair, MAS AMEDDA, takes over.

MAS AMEDDA: Order! We shall have order...

Things settle down a little. The Federation box settles next to AMIDALA. PRINCE BAIL ORGANA moves his box into the arena.

BAIL ORGANA: Alderaan seconds the motion for a vote of no confidence in Chancellor Valorum.

MAS AMEDDA: The motion has been seconded by Bail Organa of Alderaan.

MAS AMEDDA turns to the confused VALORUM, and whispers something to him.

BAIL ORGANA: There must be no delays. The motion is on the floor and must be voted upon in this session.

LOTT DOD: The Trade Federation moves the motion be sent to the procedures committee for study.

The assembly begins to chant. VALORUM talks to MAS AMEDDA.

ASSEMBLY: Vote now! Vote now! Vote now!

PALPATINE stands next to AMIDALA.

PALPATINE: You see, Your Majesty, the tide is with us... Valorum will be voted out, I assure you, and they will elect in a new Chancellor, a strong Chancellor, one who will not let our tragedy continue...

MAS AMEDDA: The Supreme Chancellor requests a recess. Tomorrow we will begin the vote.

The Federation delegation is furious. VALORUM turns to PALPATINE.

VALORUM: Palpatine, I thought you were my ally...my friend. You have betrayed me! How could you do this?

EXT. PALACE OF THE JEDI—BALCONY—SUNSET

OBI-WAN and QUI-GON stand outside the palace on a balcony.

OBI-WAN: The boy will not pass the Council's tests, Master, and you know it. He is far too old.
QUI-GON: Anakin will become a Jedi...I promise you.
OBI-WAN: Don't defy the Council, Master...not again.
QUI-GON: I will do what I must.
OBI-WAN: Master, you could be sitting on the Council by now if you would just follow the code. They will not go along with you this time.
QUI-GON: You still have much to learn, my young apprentice.

INT. PALACE OF THE JEDI—COUNCIL CHAMBERS—SUNSET

ANAKIN stands before the TWELVE JEDI. MACE WINDU holds a small hand-held viewing screen. In rapid succession, images flash across the screen.

ANAKIN: A ship...a cup...a speeder.

MACE WINDU turns the view screen off and nods toward YODA.

YODA: Good, good, young one. How feel you?
ANAKIN: Cold, sir.
YODA: Afraid are you?
ANAKIN: No, sir.
MACE WINDU: Afraid to give up your life?
ANAKIN: I don't think so.

ANAKIN hesitates for a moment.

YODA: See through you, we can.
MACE WINDU: Be mindful of your feelings...
KI-ADI: Your thoughts dwell on your mother.
ANAKIN: I miss her.
YODA: Afraid to lose her...I think.
ANAKIN: *(a little angry)* What's that got to do with anything?
YODA: Everything. Fear is the path to the dark side...fear leads to anger...anger leads to hate...hate leads to suffering.
ANAKIN: *(angrily)* I am not afraid!
YODA: A Jedi must have the deepest commitment, the most serious mind. I sense much fear in you.
ANAKIN: *(quietly)* I am not afraid.

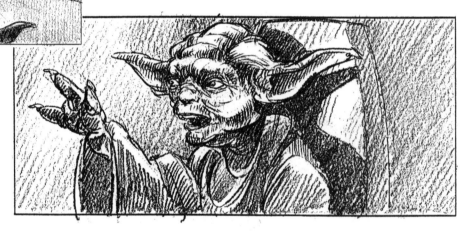

YODA: Then continue, we will.

INT. PALPATINE'S QUARTERS—SUNSET

QUEEN AMIDALA is standing, staring out the window, with JAR JAR. The lights of the city shimmer before them. EIRTAÉ and SABÉ stand near the door. JAR JAR turns to face the QUEEN and sees her sadness.

JAR JAR: Mesa wonder why da guds invent pain?
AMIDALA: To movitate us, I imagine...
JAR JAR: Yousa tinken yousa people ganna die?
AMIDALA: I don't know.
JAR JAR: Gungans ganna get pasted too, eh?
AMIDALA: I hope not.
JAR JAR: Gungans no die'n without a fight...wesa warriors. Wesa gotta grande army. Dat why you no liken us, metinks.

PALPATINE and CAPTAIN PANAKA rush into the room and bow before the QUEEN.

CAPT. PANAKA: Your Highness, Senator Palpatine has been nominated to succeed Valorum as Supreme Chancellor.

PALPATINE: A surprise, to be sure, but a welcome one. I promise, Your Majesty, if I am elected, I will bring democracy back to the Republic. I will put an end to corruption. The Trade Federation will lose its influence over the bureaucrats, and our people will be freed...

AMIDALA: Who else has been nominated?

CAPT. PANAKA: Bail Antilles of Alderaan and Ainlee Teem of Malastare.

PALPATINE: I feel confident...our "situation" will create a strong sympathy vote for us...I will be Chancellor, I promise you.

AMIDALA: I fear by the time you have control of the bureaucrats, Senator, there will be nothing left of our cities, our people, our way of life...

PALPATINE: I understand your concern, Your Majesty; unfortunately, the Federation has possession of our planet. The law is in their favor.

AMIDALA: With the Senate in transition, there is nothing more I can do here... Senator, this is your arena. I feel I must return to mine. I have decided to go back to Naboo. My place is with my people.

PALPATINE: Go back!! But, Your Majesty, be realistic! You would be in danger. They will force you to sign the treaty.

AMIDALA: I will sign no treaty, Senator. My fate will be no different from that of our people. Captain!

CAPT. PANAKA: Yes, Your Highness?

AMIDALA: Ready my ship!

PALPATINE: Please, Your Majesty, stay here...where it's safe.

AMIDALA: No place is safe, if the Senate doesn't condemn this invasion. It is clear to me now that the Republic no longer functions as a democracy. If you win the election, Senator, I know you will do everything possible to stop the Federation. I pray you will bring sanity and compassion back to the Senate.

AMIDALA and her RETINUE exit the room. PALPATINE has a self-satisfied smile on his face.

INT. TEMPLE OF THE JEDI—COUNCIL CHAMBERS—TWILIGHT

ANAKIN, OBI-WAN, and QUI-GON stand before the TWELVE MEMBERS OF THE JEDI COUNCIL.

YODA: ...Correct you were, Qui-Gon.

MACE WINDU: His cells contain a very high concentration of midi-chlorians.

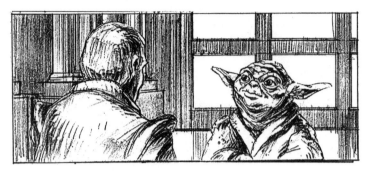

KI-ADI: The Force is strong with him.
QUI-GON: He's to be trained, then.

The COUNCIL MEMBERS look to one another.

MACE WINDU: No. He will not be trained.

ANAKIN is crestfallen; tears begin to form in his eyes.

QUI-GON: No??!!

OBI-WAN smiles.

MACE WINDU: He is too old. There is already too much anger in him.
QUI-GON: He is the chosen one...you must see it.
YODA: Clouded, this boy's future is. Masked by his youth.
QUI-GON: I will train him, then. I take Anakin as my Padawan learner.

OBI-WAN reacts with surprise. ANAKIN watches with interest.

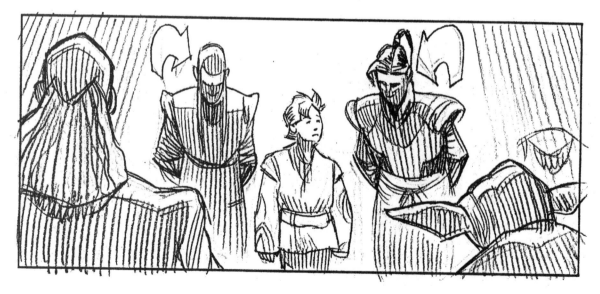

YODA: An apprentice, you have, Qui-Gon. Impossible, to take on a second.

MACE WINDU: We forbid it.

QUI-GON: Obi-Wan is ready...

OBI-WAN: I am ready to face the trials.

YODA: Ready so early, are you? What know you of ready?

ANAKIN watches as QUI-GON and OBI-WAN exchange angry looks.

QUI-GON: Headstrong...and he has much to learn about the living Force, but he is capable. There is little more he will learn from me.

YODA: Our own counsel we will keep on who is ready. More to learn, he has...

MACE WINDU: Now is not the time for this...the Senate is voting for a new Supreme Chancellor. Queen Amidala is returning home, which will put pressure on the Federation, and could widen the confrontation.

YODA: And draw out the Queen's attacker.

KI-ADI: Events are moving fast...too fast.

MACE WINDU: Go with the Queen to Naboo and discover the identity of this dark warrior. That is the clue we need to unravel this mystery of the Sith.

YODA: Young Skywalker's fate will be decided later.

QUI-GON: I brought Anakin here; he must stay in my charge. He has nowhere else to go.

MACE WINDU: He is your ward, Qui-Gon...we will not dispute that.

YODA: Train him not. Take him with you, but train him not!

MACE WINDU: Protect the Queen, but do not intercede if it comes to war until we have the Senate's approval.

YODA: May the Force be with you.

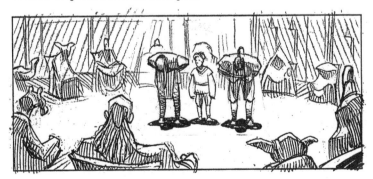

OBI-WAN, QUI-GON, and ANAKIN leave.

EXT. CORUSCANT—SENATE LANDING PLATFORM—NIGHT

QUI-GON, OBI-WAN, and ANAKIN stand on the landing platform outside the ship. ARTOO whistles a happy tune as he leans over the edge of the platform, watching the traffic. Suddenly, he leans over too far and falls overboard. After a moment, he reappears, using his on-board jets to propel himself back onto the landing platform. The wind whips at ANAKIN as he listens to the JEDI.

OBI-WAN: It is not disrespect, Master, it is the truth.

QUI-GON: From your point of view...

OBI-WAN: The boy is dangerous...they all sense it. Why can't you?

QUI-GON: His fate is uncertain, not dangerous. The Council will decide Anakin's future...that should be enough for you. Now get on board!

OBI-WAN reluctantly boards the Naboo spacecraft followed by ARTOO. QUI-GON goes over to ANAKIN.

ANAKIN: Master Qui-Gon, sir, I do not wish to be a problem.

QUI-GON: You won't be, Annie...I'm not allowed to train you, so I want you to watch me and be mindful...always remember, your focus determines your reality. Stay close to me and you will be safe.

ANAKIN: Master, sir...I've been wondering...what are midi-chlorians?

QUI-GON: Midi-chlorians are a microscopic life form that resides within all living cells and communicates with the Force.

ANAKIN: They live inside of me?

QUI-GON: In your cells. We are symbionts with the midi-chlorians.

ANAKIN: Symbionts?

QUI-GON: Life forms living together for mutual advantage. Without the midi-chlorians, life could not exist, and we would have no knowledge of the Force. They continually speak to you, telling you the will of the Force.

ANAKIN: They do??

QUI-GON: When you learn to quiet your mind, you will hear them speaking to you.

ANAKIN: I don't understand.

QUI-GON: With time and training, Annie...you will.

Two taxis pull up, and CAPTAIN PANAKA, SENATOR PALPATINE, TWENTY OR SO TROOPS, GUARDS, and OFFICERS walk briskly toward the ship, followed by QUEEN AMIDALA, PADMÉ, EIRTAÉ, and finally, JAR JAR. AMIDALA and her HANDMAIDENS stop before the JEDI.

QUI-GON: (*Cont'd*) Your Highess, it is our pleasure to continue to serve and protect you.
AMIDALA: I welcome your help. Senator Palpatine fears the Federation means to destroy me.
QUI-GON: I promise you, I will not let that happen.

AMIDALA enters the ship, followed by her HANDMAIDENS. JAR JAR hugs QUI-GON and ANAKIN.

JAR JAR: Wesa goen home!

They ALL move onto the ship. The ship takes off.

INT. NABOO PALACE—THRONE ROOM—THEED—NIGHT

NUTE and RUNE stand before a hologram of DARTH SIDIOUS.

DARTH SIDIOUS: The Queen is on her way to you. I regret she is of no further use to us. When she gets there, destroy her.
NUTE: Yes, my Lord.
DARTH SIDIOUS: Viceroy, is the planet secure?
NUTE: Yes, my Lord, we have taken over the last pockets of primitive life forms. We are in complete control of the planet now.
DARTH SIDIOUS: Good. I will see to it that in the Senate, things stay as they are. I am sending Darth Maul to join you. He will deal with the Jedi.
NUTE: Yes, My Lord.

DARTH SIDIOUS fades off.

RUNE: A Sith lord here with us?!!

INT. SPACE—NABOO SPACECRAFT COCKPIT

ANAKIN stands next to the PILOT, RIC OLIÉ, pointing to various buttons and gauges.

ANAKIN: ...and that one?
RIC OLIÉ: The forward stabilizer.
ANAKIN: And those control the pitch?
RIC OLIÉ: You catch on pretty quick.

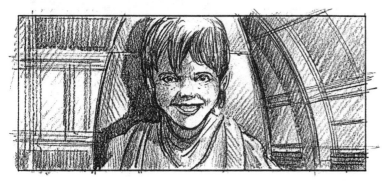

INT. NABOO SPACECRAFT—QUEEN'S CHAMBERS

SABÉ and EIRTAÉ stand behind QUEEN AMIDALA as she talks with QUI-GON and CAPTAIN PANAKA. OBI-WAN and JAR JAR watch.

CAPT. PANAKA: The moment we land the Federation will arrest you, and force you to sign the treaty.
QUI-GON: I agree...I'm not sure what you hope to accomplish by this.
AMIDALA: I'm going to take back what's ours.
CAPT. PANAKA: There are only twelve of us, Your Highness... we have no army.
QUI-GON: I cannot fight a war for you, Your Highness, only protect you.
AMIDALA: Jar Jar Binks!

JAR JAR looks around, puzzled.

JAR JAR: Mesa, Your Highness?
AMIDALA: Yes. I need your help.

INT. NABOO CRUISER COCKPIT—DAY

The Naboo Cruiser heads toward the lush green planet. There is only one Federation battle cruiser orbiting. OBI-WAN and CAPTAIN PANAKA spot it on the view screen.

PANAKA: The blockade's gone.
OBI-WAN: The war's over...No need for it now.
RIC OLIÉ: I have one battleship on my scope.

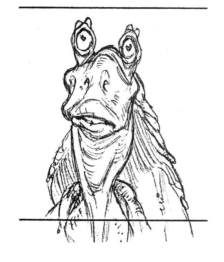

OBI-WAN: A droid control ship.
PANAKA: They've probably spotted us.
OBI-WAN: We haven't much time.

INT. NABOO SPACECRAFT—MAIN HOLD

The QUEEN, CAPTAIN PANAKA, TROOPS, and HANDMAIDENS get ready to disembark as the ship lands. The elevator door slides open, and ANAKIN emerges into the hold area. He sees PADMÉ and runs up to her.

ANAKIN: Hi! Where have you been?
PADMÉ: Annie! What are you doing here?
ANAKIN: I'm with Qui-Gon...but...they're not going to let me be a Jedi. I'm too old.
PADMÉ: This is going to be dangerous, Annie.
ANAKIN: Is it? I can help... Where are we going?
PADMÉ: To war, I'm afraid. The Queen has had to make the most difficult decision of her life. She doesn't believe in fighting, Annie. We are a peaceful people...
ANAKIN: I *want* to help...I'm glad you're back.

ANAKIN smiles. PADMÉ smiles back.

EXT. NABOO SWAMP—DAY

The Naboo spacecraft has landed in the Gungan swamp. TROOPS unload the ships in the background as OBI-WAN approaches QUI-GON.

OBI-WAN: Jar Jar is on his way to the Gungan city, Master.

QUI-GON's thoughts are elsewhere.

QUI-GON: Good.

OBI-WAN and QUI-GON stand silently for a moment.

OBI-WAN: Do you think the Queen's idea will work?
QUI-GON: The Gungans will not be easily swayed, and we cannot use our power to help her.
OBI-WAN: I'm...I'm sorry for my behavior, Master. It is not my place to disagree with you about the boy. I am grateful you think I am ready for the trials.

QUI-GON looks at him for a long moment.

QUI-GON: You have been a good apprentice. You are much wiser than I am, Obi-Wan. I foresee you will become a great Jedi Knight.

EXT. NABOO SWAMP—UNDERWATER—DAY (FX)

JAR JAR swims down into Bubble City.

INT. OTOH GUNGA—CITY SQUARE

JAR JAR enters the main square of the bubble city. He stands, stunned, in amazement and fear. He is nervous and shaking.

JAR JAR: Ello! Where das everybody?

The plaza is empty. He notices that many of the buildings are shot up as if there had been a battle of some kind.

EXT. NABOO SWAMP LAKE—DAY

JAR JAR exits the swamp lake and walks over to QUEEN AMIDALA, CAPTAIN PANAKA, OBI-WAN, and QUI-GON. PADMÉ, EIRTAÉ, RABÉ, ANAKIN and ARTOO, FOUR PILOTS, and EIGHT GUARDS stand in the background near the starship.

JAR JAR: Dare-sa nobody dare. All gone. Some kinda fight, I tink. Sorry, no Gungas...no Gungas.
CAPT. PANAKA: Do you think they have been taken to camps?
OBI-WAN: More likely they were wiped out.
JAR JAR: No...mesa no tink so. Gungan hiden. When in trouble, go to sacred place. Mackineeks no find them dare.
QUI-GON: Do you know where they are?

EXT. NABOO SWAMP—DAY

The GROUP follows JAR JAR as he moves through the swamp. JAR JAR stops and sniffs the air. The GROUP stops behind him.

JAR JAR: Dissen it.

JAR JAR makes a strange chattering noise. Suddenly, out of nowhere, CAPTAIN TARPALS and SIX OTHER GUNGAN TROOPS riding on KAADUS emerge from the brush.

JAR JAR: *(Cont'd)* Heyo-dalee, Captain Tarpals.
CAPT. TARPALS: Binks!! Noah gain!
JAR JAR: We comen to see da boss.

CAPTAIN TARPALS rolls his eyes.

CAPT. TARPALS: Ouch time, Binks... Ouch time for all-n youse.

EXT. NABOO SACRED TEMPLE RUINS—DAY

JAR JAR, QUEEN AMIDALA, ANAKIN, ARTOO, QUI-GON, OBI-WAN, PADMÉ, RABÉ, EIRTAÉ, and the rest of her group are led through a clearing full of GUNGAN refugees. At the far end are the ruins of a grand temple with massive carved heads. BOSS NASS and several other COUNCIL MEMBERS walk out on the top of a three-quarter-submerged head.

BOSS NASS: Jar Jar, yousa payen dis time. Who's da uss-en others??

QUEEN AMIDALA steps forward. CAPTAIN PANAKA and the JEDI stand behind her.

AMIDALA: I am Queen Amidala of the Naboo...I come before you in peace.

BOSS NASS: Naboo biggen. Yousa bringen da Mackineeks... Day busten uss-en omm. Yousa all bombad. Yousa all die'n, mesa tink.

CAPTAIN PANAKA and HALF A DOZEN GUARDS and PILOTS look around nervously, and the GUNGAN TROOPS lower their long power poles. The JEDI stay relaxed. ANAKIN watches everything with great interest.

AMIDALA: We wish to form an alliance...

Suddenly, PADMÉ steps forward.

PADMÉ: Your Honor...

ARTOO whistles a quiet "uh oh."

BOSS NASS: Whosa dis?

PADMÉ: I am Queen Amidala. *(points to Queen)* This is my decoy...my protection...my loyal bodyguard.

ANAKIN is stunned. OBI-WAN and QUI-GON give each other a knowing look.

PADMÉ: *(Cont'd)*...I am sorry for my deception, but under the circumstances it has become necessary to protect myself. Although we do not always agree, Your Honor, our two great societies have always lived in peace...until now. The Trade Federation has destroyed all that we have worked so hard to build. You are in hiding, my people are in camps. If we do not act quickly, all will be lost forever...I ask you to help us...no, I beg you to help us.

PADMÉ drops to her knees and prostrates herself before BOSS NASS. There is a gasp from CAPTAIN PANAKA, HIS TROOPS, and the HANDMAIDENS.

PADMÉ: *(Cont'd)* We are your humble servants...our fate is in your hands.

Slowly, CAPTAIN PANAKA and his TROOPS bow down before the GUN-GAN COUNCIL. Then the HANDMAIDENS, ANAKIN, and finally the JEDI. The GUNGANS are puzzled by this. BOSS NASS begins to laugh.

BOSS NASS: Yousa no tinken yousa greater den da Gungans ...Mesa like dis. Maybe wesa bein friends.

INT. NABOO PALACE—THRONE ROOM—DAY

NUTE, RUNE, and DARTH MAUL walk with a hologram of DARTH SID-IOUS.

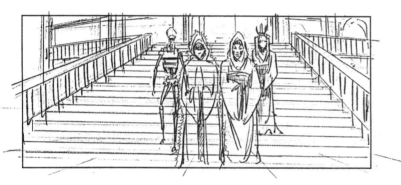

NUTE: ...we've sent out patrols. We've already located their star-ship in the swamp... It won't be long, My Lord.
DARTH SIDIOUS: This is an unexpected move for her. It's too aggressive... Lord Maul, be mindful.
DARTH MAUL: Yes, my Master.
DARTH SIDIOUS: Be patient... Let them make the first move.

EXT. NABOO EDGE OF SWAMP/GRASS PLAINS—DAY

A GUNGAN SENTRY sits on the top of an ancient temple head, searching the landscape with a pair of electrobinoculars. He sees something and yells down to ANAKIN at the foot of the statue.

GUNGAN LOOKOUT: Daza comen!
ANAKIN: All right. They're here!

ANAKIN yells and runs over to PADMÉ and the JEDI, who are dis-cussing a battle plan with FIVE GUNGAN GENERALS. SABÉ and EIRTAÉ stand nearby. BOSS NASS puts his arm around JAR JAR.

BOSS NASS: Yousa doen grand. Jar Jar bringen da Naboo together.
JAR JAR: Oh, no, no, no...
BOSS NASS: So, wesa maken yousa Bombad General.

JAR JAR: General??! Oh, no...

JAR JAR's eyes roll back, his tongue flops out and he faints.
FOUR SPEEDERS pull up to the GROUP. CAPTAIN PANAKA and a DOZEN OR SO GUARDS and PILOT pile out and join the group.

PADMÉ: What is the situation?

CAPT. PANAKA: Almost everyone's in camps. A few hundred police and guards have formed an underground movement. I brought as many of the leaders as I could. The Federation Army's also much larger than we thought, and much stronger. Your Highness, this is a battle I do not think we can win.

PADMÉ: The battle is a diversion. The Gungans must draw the Droid Army away from the cities. We can enter the city using the secret passages on the waterfall side. Once we get to the main entrance, Captain Panaka will create a diversion, so that we can enter the palace and capture the Viceroy. Without the Viceroy, they will be lost and confused.

QUI-GON and OBI-WAN look on with interest.

PADMÉ: *(Cont'd)* What do you think, Master Jedi?

QUI-GON: The Viceroy will be well guarded.

CAPT. PANAKA: The difficulty's getting into the throne room. Once we're inside, we shouldn't have a problem.

QUI-GON: There is a possibility with this diversion many Gungans will be killed.

BOSS NASS: Wesa ready to do are-sa part.

JAR JAR smiles a very worried and sheepish grin. ANAKIN watches with interest, as does ARTOO.

PADMÉ: We have a plan which should immobilize the Droid Army. We will send what pilots we have to knock out the Droid control ship which is orbiting the planet. If we can get past their rayshields, we can sever communication and their droids will be helpless.

QUI-GON: A well-conceived plan. However, there's great risk. The weapons on your fighters may not penetrate the shields on the control ship.

OBI-WAN: And there's an even bigger danger. If the Viceroy escapes, Your Highness, he will return with another droid army.

PADMÉ: That is why we must not fail to get the Viceroy. Everything depends on it.

INT. THEED—PALACE—THRONE ROOM—DAY

NUTE, RUNE, DARTH MAUL, OOM-9, and a hologram of DARTH SIDIOUS walk through the throne room.

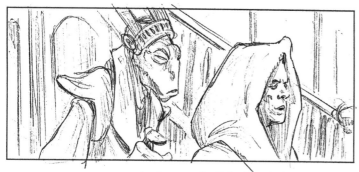

DARTH SIDIOUS: ...she is more foolish than I thought.

NUTE: We are sending all available troops to meet this army of hers assembling near the swamp. It appears to be made up of primitives. We do not expect much resistance.

OOM-9: I am increasing security at all Naboo detention camps.

DARTH MAUL: I feel there is more to this, My Master. The two Jedi may be using the Queen for their own purposes.

DARTH SIDIOUS: The Jedi cannot become involved. They can only protect the Queen. Even Qui-Gon Jinn will not break that covenant... This will work to our advantage...

NUTE: I have your approval to proceed, then, My Lord.

DARTH SIDIOUS: Proceed. Wipe them out...all of them.

EXT. NABOO SWAMP LAKE—DAY (FX)

All is peaceful. SMALL CRITTERS drink out of a large swamp lake. Suddenly, there is a disturbance in the middle of the lake. A rush of bubbles, then a GUNGAN SOLDIER riding a KAADU emerges from the water, followed by SEVERAL OTHERS. FROGS and OTHER LITTLE ANI-MALS flee in all directions as the GUNGAN ARMY marches through the swamp. The KAADU shake themselves off as they exit the lake. When JAR JAR's KAADU shakes off, JAR JAR falls off.

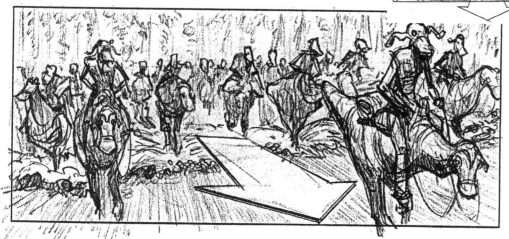

SOLDIERS on huge, lizard-like FAMBAAS with large shield genera-tors mounted on their backs follow the marching WARRIORS. The GUNGAN ARMY heads out of the swamp and onto the rolling grassy hills.

HUNDREDS OF GUNGAN WARRIORS march in long lines toward the horizon.

Federation tanks move up to a ridge and stop. In the distance they see the GUNGAN ARMY marching toward them. The GUNGAN GENERAL CEEL sees the tanks on the ridge and orders a halt. The GUNGANS are spread out in a large line. JAR JAR is nervous. GEN-ERAL CEEL signals to the shield operators.

GENERAL CEEL: Energize the shields!

A red ray shoots out of the generator and blasts into a large dish on the back of a second FAMBAA and spreads like an umbrella over the assembled WARRIORS.

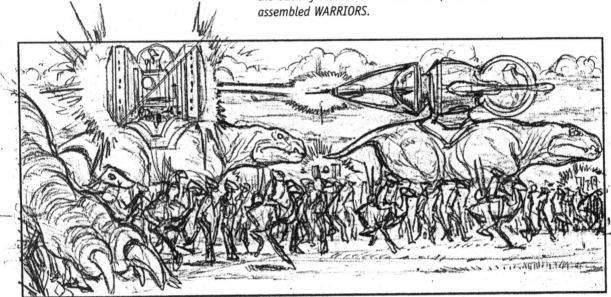

EXT. THEED—CENTRAL PLAZA—DAY

PADMÉ, followed by EIRTAÉ, OBI-WAN, QUI-GON, ANAKIN, and ARTOO, stealthily makes her way toward the entrance to the main hangar. They are followed by about TWENTY NABOO GUARDS, PILOTS, and TROOPS. They stop, and PADMÉ uses a small red laser light to signal across the plaza to CAPTAIN PANAKA, RABÉ and TWENTY OTHER ASSORTED NABOO TROOPS. They signal back. QUI-GON leans over to ANAKIN.

QUI-GON: Once we get inside, Annie, you find a safe place to hide and stay there.

ANAKIN: Sure.

QUI-GON: And stay there!

DROID TROOPS mill about the tank-filled plaza. At the far end of the plaza, SEVERAL DROIDS begin to run and fire. NABOO SOLDIERS begin to fire back at the BATTLE DROIDS.

As the ruckus erupts at one end of the plaza, PADMÉ and HER TROOPS rush into the main hangar. CAPTAIN PANAKA and HIS SOLDIERS continue to engage the DROIDS outside.

INT. THEED—CENTRAL HANGAR—DAY

ALARMS ARE SOUNDING as PADMÉ, the JEDI, ANAKIN, EIRTAÉ, and PADMÉ's TROOPS rush into the hangar. BATTLE DROIDS begin firing at them as they run for cover. ANAKIN runs under a Naboo fighter. The JEDI deflect bolts aimed at PADMÉ back onto the BATTLE DROIDS, causing them to EXPLODE.

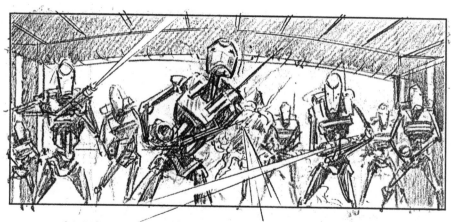

INT. THEED—PALACE THRONE ROOM—DAY

NUTE, RUNE, and FOUR COUNCIL MEMBERS watch the plaza battle on a large view screen.

NUTE: I thought the battle was going to take place far from here...this is too close!

RUNE: What is going on?

DARTH MAUL enters the throne room.

DARTH MAUL: I told you there was more to this...the Jedi are involved.

EXT. NABOO GRASS PLAINS—DAY (FX)

The Federation tanks begin to fire on the GUNGANS, but they are protected by their energy shield. The tanks stop firing, and the GUN-GANS CHEER, until they see the doors to the massive transports

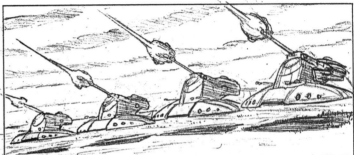

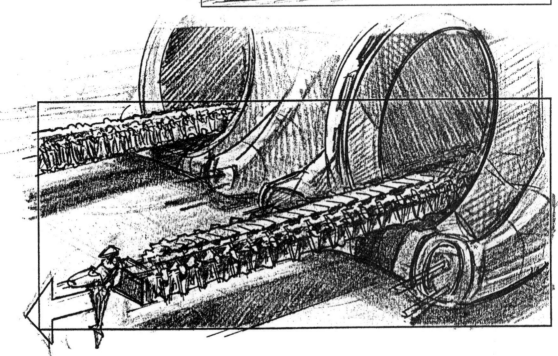

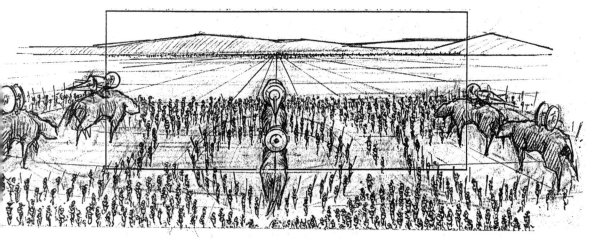

open, and racks of BATTLE DROIDS are pulled out and lined up by a squad of STAPS.

The BATTLE DROIDS reconfigure into their standing position. The GUNGANS get ready for an attack. OOM-9 gives the command to move forward, and THOUSANDS OF DROIDS march toward the GUNGANS.

The GUNGANS power up their weapons. The DROIDS slowly march through the protective shield and start firing. The GUNGANS throw their power poles and fling small balls of energy with slingshots. The WARRIORS dump large balls of energy into mortars that heat up and fire the energy goo onto the BATTLE DROIDS, causing them to short out.

The battle rages and the GUNGANS defend their shield generators against the ARMY OF DROIDS. OOM-9 watches from a tank on a hill overlooking the battle.

INT. THEED—CENTRAL HANGAR—DAY

ANAKIN hides behind one of the Naboo fighters, ducking as large bolts whiz past and EXPLODE near him. PADMÉ and the TWO JEDI destroy BATTLE DROIDS right and left. The QUEEN'S TROOPS and EIRTAÉ also blast away at the DROIDS. PADMÉ signals to her pilots.

PADMÉ: Get to your ships!

The PILOTS and ARTOO UNITS run for the Naboo fighter craft stacked in the hangar bay. ONE OF THE PILOTS jumps into a fighter right above where ANAKIN is hiding.

FIGHTER PILOT: Better find a new hiding place, kid. I'm taking this ship.

The ship begins to levitate out of the hangar. BATTLE DROIDS fire at it as it falls in behind five other fighters. ARTOO whistles to ANAKIN from a second fighter not far away. ANAKIN runs and jumps into the second fighter to hide.

EXT. THEED—CENTRAL PLAZA—DAY (FX)

Two Naboo starfighters exit the main hangar. A tank fires at them, hitting one of them, which causes it to pinwheel into the ground and EXPLODE.

INT. THEED—CENTRAL HANGAR—DAY

CAPTAIN PANAKA, SABÉ and NABOO TROOPS rush into the hangar and overwhelm the few remaining BATTLE DROIDS. PADMÉ, OBI-WAN, and QUI-GON join forces with CAPTAIN PANAKA.

PADMÉ: My guess is the Viceroy is in the throne room.

She looks to QUI-GON.

QUI-GON: I agree.

They start to head for the exit, on the way passing the fighter where ANAKIN is hiding. ARTOO whistles a greeting as ANAKIN peeps out of the cockpit.

ANAKIN: Hey! Wait for me.
QUI-GON: No, Annie, you stay there. Stay right where you are.
ANAKIN: But, I...
QUI-GON: Stay in that cockpit.

They head for the exit. As they are about to go through the door, suddenly everyone scatters, revealing DARTH MAUL standing in the doorway. CAPTAIN PANAKA, PADMÉ, and HER TROOPS back away. QUI-GON AND OBI-WAN step forward.

QUI-GON: (Cont'd) We'll handle this...

The TWO JEDI take off their capes and ignite their laser swords. DARTH MAUL takes off his cape, and ignites his laser sword. Both ends of the sword light up.

At the far end of the hangar, SIX WHEEL DROIDS roll in and transform into their battle positions. ARTOO calls ANAKIN's attention to the DROIDS. The JEDI begin to fight the SITH LORD.

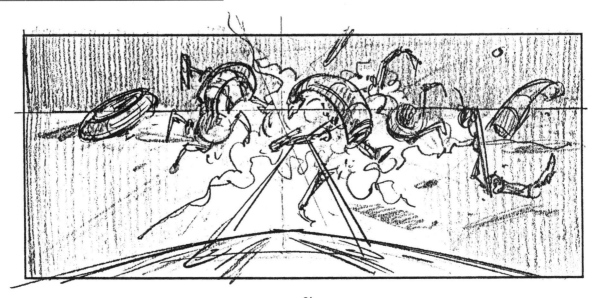

ANAKIN: Oh, no...

The DROIDS begin to advance and start firing on PADMÉ and HER TROOPS.

ANAKIN: (Cont'd) We gotta do something, Artoo.

ARTOO whistles a reply. Suddenly, the ship's systems go on, and the ship begins to levitate.

ANAKIN: (Cont'd) All right, thanks Artoo! Great idea! I'll take over. Let's see...

ANAKIN steers the ship toward the DROIDS. He pushes a button, and the ship begins to shake.

ANAKIN: (Cont'd) Where's the trigger? Oops, wrong one... Maybe this one...

ANAKIN pushes a second button, and the lasers begin to fire, wiping out several DESTROYER DROIDS. ARTOO whistles a cheer.

ANAKIN: (Cont'd) Yeah, all right. "Droid blaster." Yeah!

The JEDI are engaged in a fierce sword fight with DARTH MAUL. They have moved into the center of the hangar. While the WHEEL DROIDS are momentarily distracted by ANAKIN, CAPTAIN PANAKA, PADMÉ, and HER TROOPS exit into a palace hallway.

The WHEEL DROIDS start firing at ANAKIN. There are EXPLOSIONS all around him.

ANAKIN: (Cont'd) Oops...shield up! Always on the right... shields always on the right.

ANKIN flips several switches, and the after-burner ignites.

ANAKIN: *(Cont'd)* I know we're moving. I'll shut the energy drive down.

The fighter rockets out of the hangar. ARTOO and ANAKIN hold on for dear life.

ANAKIN: *(Cont'd)* Oops!! Wrong one.

ARTOO beeps.

ANAKIN: *(Cont'd)* I'm not doing anything!

ARTOO beeps.

ANAKIN: *(Cont'd)* I know...I didn't push anything.

The SITH LORD's moves are incredible. He is fighting the TWO JEDI at once, flipping into the air, outmaneuvering them at every turn.

INT. NABOO STARFIGHTER—COCKPIT—SPACE

The Naboo fleet leaves the planet and heads toward the space station.

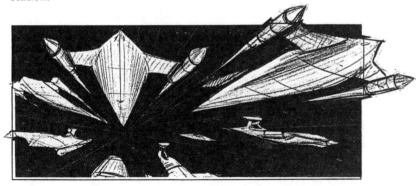

RIC OLIÉ: Bravo Flight A, take on the fighters. Flight B, make the run on the transmitter.

BRAVO TWO: Roger, Bravo Leader.

The fleet approaches the space station. Many Federation fighters exit the hangars and attack.

RIC OLIÉ: Enemy fighters straight ahead!

EXT. NABOO GRASS PLAINS—DAY

JAR JAR's clumsiness works for him in the battle. He gets caught up in the wiring of a blasted DROID, dragging the torso around with him, the DROID's gun firing randomly, accidentally blasting SEVERAL DROIDS in the process.

OOM-9 decides to send in the WHEEL DROIDS and gives the signal. HUNDREDS OF WHEEL DROIDS roll out of the transports and head

down toward the battle. They slowly roll through the deflector shields, then transform themselves once they get on the other side. The GUNGANS blast the WHEEL DROIDS with energy balls. The DESTROYER DROIDS blast many GUNGANS.

INT. NABOO STARFIGHTER—COCKPIT—SPACE

A giant dogfight ensues. ANAKIN's fighter flies into space above Naboo. ARTOO beeps a worried concern.

ANAKIN: The Autopilot is searching for what other ships?

ARTOO beeps and whistles.

ANAKIN: (Cont'd) There is no manual override, Artoo. You'll have to rewire it or something.

ARTOO chirps that he's trying.

ANAKIN: (Cont'd) Look! There they are! That's where the Autopilot is taking us.

ANAKIN's fighter flies toward the Federation Battleship.

INT. THEED—CENTRAL HANGAR—DAY

The SITH LORD drives the JEDI out of the hangar and into a power generator area next door.

INT. THEED—POWER GENERATOR PIT—DAY

Three swords are crossed in an intense display of swordsmanship. The JEDI and the SITH LORD fight their way across the narrow bridge of the Theed power generator. DARTH MAUL jumps onto the bridge above them. The JEDI follow, one in front of the SITH LORD and one behind. They continue their sword fight.

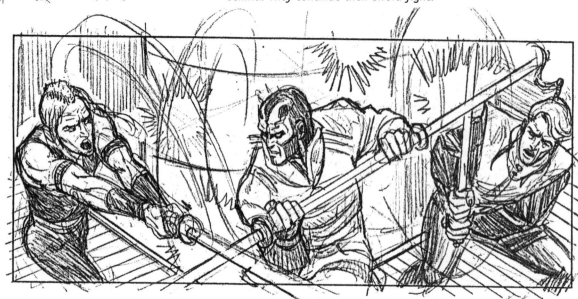

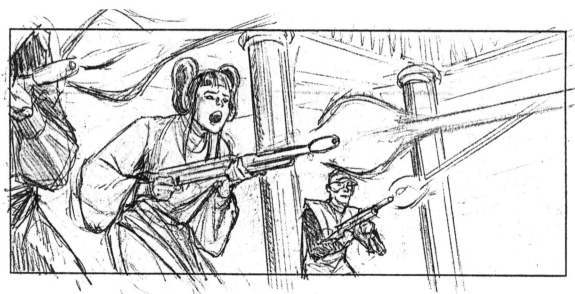

INT. THEED—PALACE—HALLWAY—DAY

PADMÉ, CAPTAIN PANAKA, EIRTAÉ, SABÉ and THEIR TROOPS are trapped in a hallway by BATTLE DROIDS.

PADMÉ: We don't have time for this, Captain.
CAPT. PANAKA: Let's try the outside stairway.

CAPTAIN PANAKA blasts a hole in the window, and they make their way outside the building onto a ledge about six stories above a raging waterfall. SABÉ, EIRTAÉ and about TWENTY NABOO SOLDIERS stay in the hallway to hold off the BATTLE DROIDS.

EXT. THEED—PALACE—OVER WATERFALL—DAY

PADMÉ, CAPTAIN PANAKA, and about TEN OTHER NABOO SOLDIERS are lined up along the ledge. They have pulled small attachments out of their pistols and fire at a ledge about four stories above them. Thin cables shoot out of the pistols and are embedded into the ledge. PADME, CAPTAIN PANAKA, and the OTHERS begin to climb up the wall.

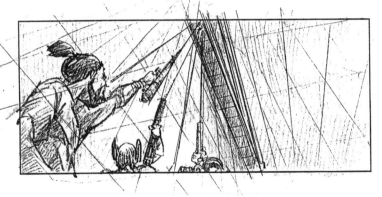

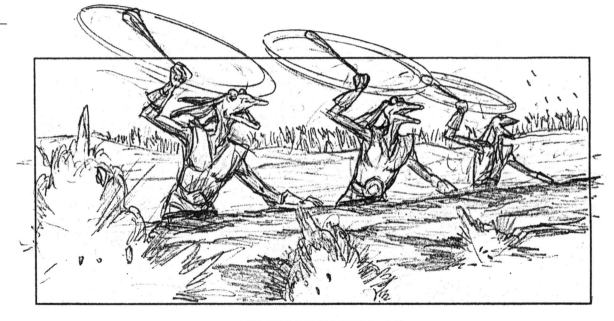

EXT. NABOO GRASS PLAINS—DAY

The GUNGAN ARMY is no match for the DESTROYER DROIDS. JAR JAR tries to run from the BATTLE DROIDS.

GENERAL CEEL: Retreat! Retreat!

The GUNGANS begin to turn and run, on foot, on their kaadu, and in wagons. JAR JAR attempts to escape on a wagon of energy balls but only manages to unhitch the back gate, causing all of the energy balls to roll out of the wagon and down the hill. JAR JAR scrambles to avoid being hit by one of the balls. FOUR DESTROYER DROIDS aren't so lucky. They get blasted by the energy balls.

The GUNGANS renew their attack on the DROID ARMY. JAR JAR's bumbling destroys several more BATTLE DROIDS.

INT. NABOO STARFIGHTER—COCKPIT—SPACE

ANAKIN finds himself in the middle of the space battle. A ship explodes behind him (over his left shoulder).

ANAKIN: Whoo, boy! This is tense!

He looks forward to see enemy ships approaching head on.

ANAKIN: *(Cont'd)* Oops! Artoo, get us off Autopilot!

ARTOO screams a reply.

ANAKIN: *(Cont'd)* I've got control?

ANAKIN flips switches.

ANAKIN: *(Cont'd)* Okay, let's go left!

He moves the controls left and the ship responds, turning left.

ANAKIN: *(Cont'd)* Yes...I've got control. You did it, Artoo!

ARTOO beeps.

ANAKIN: *(Cont'd)* Go back!?! Qui-Gon told me to stay in this cockpit and that's what I'm gonna do. Now c'mon!

An enemy fighter comes into his sights. ANAKIN pushes the controls and instead of firing, his fighter accelerates past the enemy ship.

ANAKIN: *(Cont'd)* Oops! Whoa!

Now the enemy ship is on his tail. He tries evasive maneuvers.

ANAKIN: *(Cont'd)* I'll try spinning, that's a good trick.

ANAKIN rolls the ship as ARTOO screams desperately.

ANAKIN: *(Cont'd)* I know we're in trouble! Hang on! The way out of this mess is the way we got into it.

ARTOO beeps a reply.

ANAKIN: *(Cont'd)* Which one? This one?

ANAKIN yanks on the reverse thrusters and the ship slows instantly— the enemy fighter shoots past and explodes against the space station.

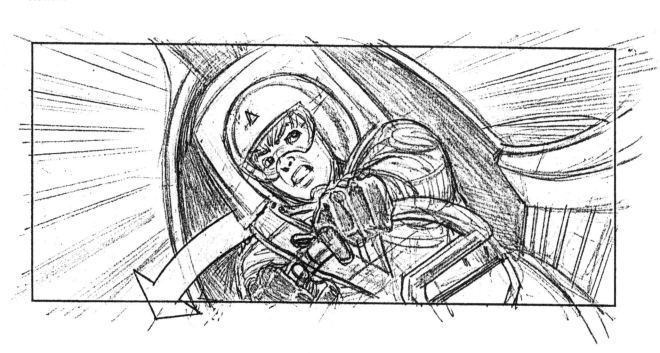

INT. NABOO STARFIGHTER—COCKPIT—SPACE

The SQUADRON attacks the space station.

RIC OLIÉ: Bravo flight...go for the central bridge.
BRAVO TWO: Roger, Bravo Leader.

The attack is fruitless.

RIC OLIÉ: Their deflector shield is too strong. We'll never get through it.

Meanwhile, ANAKIN is being chased by another fighter. ARTOO shrieks.

ANAKIN: I know, Artoo! This isn't Podracing!

The enemy ship fires and hits ANAKIN's fighter, sending it into a spin. ARTOO screams.

ANAKIN *(Cont'd)* We're hit!

ANAKIN regains control as his ship enters the space station hangar.

ANAKIN: *(Cont'd)* Great gobs of bantha poo-doo!

ANAKIN's ship dodges parked transport ships and other obstacles. A huge bulkhead blocks his way. ARTOO beeps.

ANAKIN: *(Cont'd)* I'm trying to stop! I'm trying to stop! Whoa!

ANAKIN hits the reverse thrusters and the ship skids to a stop on the hangar deck. ARTOO gives out a worried whistle.

ANAKIN: *(Cont'd)* All right! All right! Get the system started!

ANAKIN ducks down to adjust a control panel.

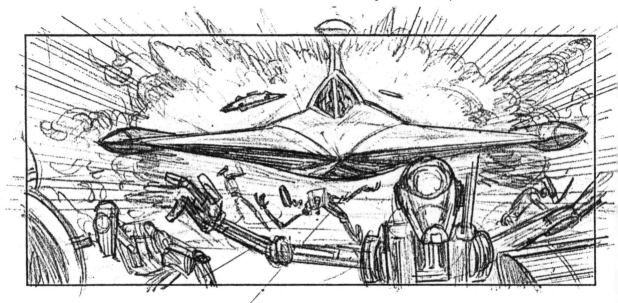

ANAKIN: *(Cont'd)* Everything's overheated. All the lights are red.

ARTOO sees DROIDS approaching, and beeps frantically.

INT. THEED—POWER GENERATOR PIT—DAY

The laser sword battle continues on the small catwalk around the vast power pit. DARTH MAUL kicks OBI-WAN off one of the ramps and he falls several levels. QUI-GON knocks the DARK LORD off another ramp, and he lands hard on a ramp two levels below. QUI-GON jumps down after him. The DARK LORD backs away along the catwalk into a small door. QUI-GON follows as OBI-WAN runs to catch up.

INT. THEED—POWER GENERATOR ELECTRIC BEAM—HALLWAY

The SITH LORD, followed by QUI-GON, enters a long hallway filled with a series of deadly rays that go on and off in a pulsing pattern that shoots down the corridor every minute or so. DARTH MAUL makes it down several walls of deadly rays before they close. QUI-

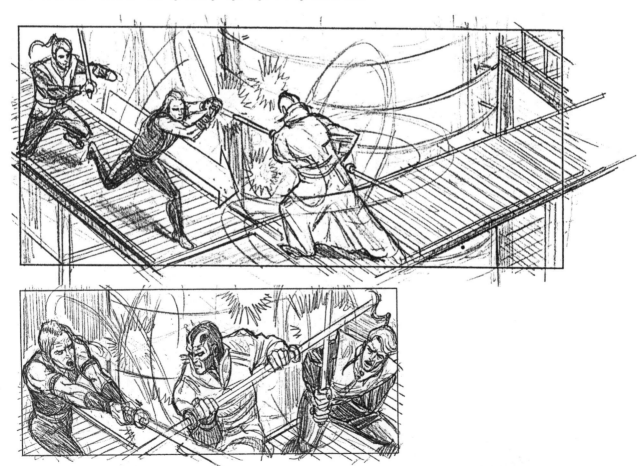

GON is one wall away from the DARK LORD. OBI-WAN is just starting into it and is five walls away from DARTH MAUL.

The JEDI must wait until the next pulse to advance down the corridor. OBI-WAN is impatient and paces, waiting for the wall of rays to open. QUI-GON sits and meditates. The SITH LORD tries to patch up his wounds.

INT. THEED—PALACE—HALLWAY TO THRONE ROOM

A window in the hallway blasts apart. PADMÉ, CAPTAIN PANAKA, and HER SOLDIERS climb into the hallway. They head for the door to the throne room. Suddenly, two DESTROYER DROIDS skitter in front of the door. PADMÉ turns around and sees TWO MORE appear at the far end of the hallway, trapping them in the middle.

PADMÉ throws down her pistol and turns to CAPTAIN PANAKA.

PADMÉ: Throw down your weapons. They win this round.
CAPT. PANAKA: But we can't...
PADMÉ: Captain, I said throw down your weapons.

CAPTAIN PANAKA and HIS MEN throw down their weapons.

EXT. NABOO GRASS PLAINS—DAY

A DESTROYER DROID blasts one of the shield generators, causing it to EXPLODE. The protective shield begins to weaken and fall apart. OOM-9 sees the shield weaken and orders his tanks forward. The GUNGAN GENERAL signals a retreat as the tanks enter the battle.

The GUNGANS flee as fast as they can. JAR JAR is blown off his KAADU and lands on one of the tank guns. A GUNGAN WARRIOR signals JAR JAR to jump off. JAR JAR is afraid. The gun swings around trying to knock JAR JAR off. JAR JAR hangs from the tank barrel as it moves along. Finally, he jumps onto a KAADU behind a GUNGAN WARRIOR. EXPLOSIONS from the tank fire are everywhere. It is chaos.

INT. THEED—POWER GENERATOR ELECTRIC BEAM—HALLWAY

The electron rays cycle as QUI-GON sits meditating. The wall of deadly rays turn away, and OBI-WAN starts running toward QUI-GON and the DARK LORD. When the wall between QUI-GON and DARTH

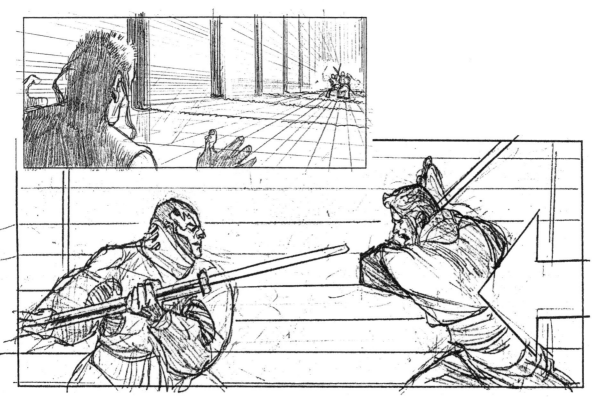

MAUL opens, QUI-GON is in a split second fighting the DARK LORD with a ferocity not seen before. They move into the area at the end of the corridor called the melting pit, a small area that is mostly made up of a deep hole.

The electron ray gates begin to close. OBI-WAN tries to make it to the melting pit but is caught one gate short. He slides to a stop just before he hits the deadly electron field.

QUI-GON and DARTH MAUL battle around the melting pit as a frustrated OBI-WAN watches.

DARTH MAUL catches QUI-GON off guard. The SITH makes a quick move, bashes his lightsaber handle into QUI-GON's chin, and runs him through. QUI-GON slumps to the floor in a heap.

EXT. NABOO GRASS PLAINS—DAY

The GUNGANS have been overrun. Some flee into the hills, chased by BATTLE DROIDS on STAPS. Many OTHERS are herded into groups by BATTLE DROIDS and DESTROYER DROIDS.

JAR JAR and GENERAL CEEL are held in a small group with OTHER OFFICERS.

JAR JAR: Dissa bad, berry bombad.
GENERAL CEEL: Mesa hopen dissa working for da Queen.

INT. THEED—PALACE THRONE ROOM—DAY

PADMÉ, CAPTAIN PANAKA, and SIX OTHER OFFICERS are brought by TEN BATTLE DROIDS before NUTE and RUNE and FOUR NEIMOIDIAN COUNCIL MEMBERS.

NUTE: Your little insurrection is at an end, Your Highness. Time for you to sign the treaty...and end this pointless debate in the Senate.

SABÉ dressed like the Queen appears in the doorway with SEVERAL TROOPS. Several destroyed battle droids can be seen in the distance.

SABÉ: I will not be signing any treaty, Viceroy, because you've lost!

NUTE and THE OTHERS are stunned to see a SECOND QUEEN. NUTE yells at the TEN GUARDS in the room.

NUTE: After her! This one is a decoy!

SIX OF THE DROIDS rush out of the throne room after SABÉ. NUTE turns to PADMÉ.

NUTE: (Cont'd) Your Queen will not get away with this.

PADMÉ slumps down on her throne and immediately hits a security button that opens a panel in her desk opposite CAPTAIN PANAKA.

PADMÉ grabs two pistols, tosses one of them to CAPTAIN PANAKA and one to an OFFICER. She takes a third pistol and BLASTS the last of the BATTLE DROIDS.

The OFFICERS rush to the door control panel as PADMÉ hits the switch to close the door. The OFFICER at the door jams the controls. CAPTAIN PANAKA throws more pistols to the OTHER GUARDS. The NEIMOIDIANS are confused and afraid.

PADMÉ: Now, Viceroy, this is the end of your occupation here.
NUTE: Don't be absurd. There are too few of you. It won't be long before hundreds of destroyer droids break in here to rescue us.

INT. THEED—POWER GENERATOR—MELTING PIT

OBI-WAN screams as the pulsing electron gate opens, and the SITH LORD attacks him. The DARK LORD is relentless in his assault on the young JEDI.

OBI-WAN and DARTH MAUL use the Force to fling objects at each other as they fight. DARTH MAUL seems to have the upper hand as OBI-WAN grows weary.

DARTH MAUL catches OBI-WAN off guard, and the JEDI slips into a melting pit. He is barely able to hold onto a nozzle on the side of the pit. DARTH MAUL grins evilly at OBI-WAN as he kicks OBI-WAN's lightsaber down the endless shaft.

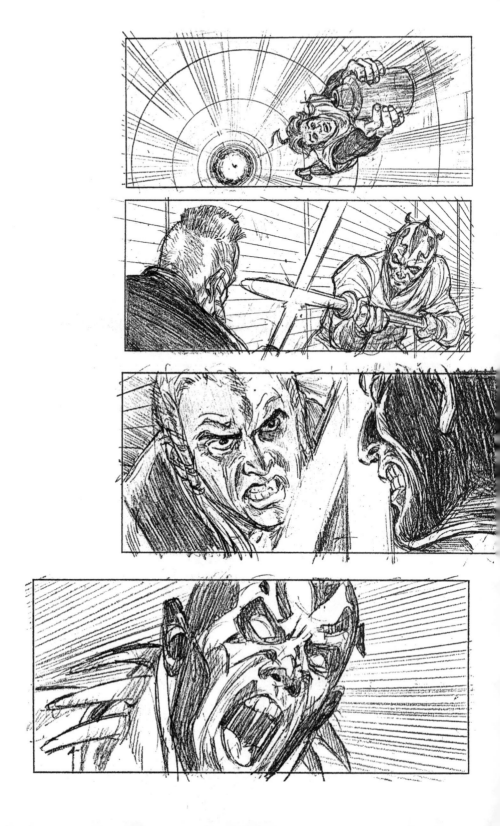

The SITH LORD smiles as he goes in for the kill. At the last moment, OBI-WAN jumps up out of the pit, calls QUI-GON's lightsaber to him, throwing DARTH MAUL off. The young JEDI swings with a vengeance, cutting the SITH down. DARTH MAUL falls into the melting pit to his death.

OBI-WAN rushes over to QUI-GON, who is dying.

OBI-WAN: Master! Master!
QUI-GON: It is too late...It's...
OBI-WAN: No!
QUI-GON: Obi-Wan, promise...promise me you'll train the boy...
OBI-WAN: Yes, Master...
QUI-GON: He is the chosen one...he will...bring balance...train him!

QUI-GON dies. OBI-WAN cradles his Master, quietly weeping.

INT. NABOO STARFIGHTER—COCKPIT—FEDERATION HANGAR

ANAKIN peeks over the edge of the cockpit to see BATTLE DROIDS surrounding the ship. He ducks back down.

ANAKIN: Uh oh. This is not good.

He looks at the dashboard to see red lights.

ANAKIN: (Cont'd) The systems are still overheated, Artoo.

The BATTLE DROID CAPTAIN walks up to the ship and sees ARTOO.

BATTLE DROID CAPTAIN: Where's your pilot?

ARTOO beeps a reply.

BATTLE DROID CAPTAIN: (Cont'd) You're the pilot?

ARTOO whistles.

BATTLE DROID CAPTAIN: (Cont'd) Let me see your identification!

ANAKIN sees the dashboard lights go from red to green.

ANAKIN: Yes...we have ignition.

He flips the switch and the engine starts.

BATTLE DROID CAPTAIN: (seeing Anakin) You! Come out of there or we'll blast you!
ANAKIN: Not if I can help it! Shields up!

ANAKIN flips a switch and the ship levitates, knocking over the BATTLE DROID CAPTAIN. The OTHER DROIDS shoot, but the lasers are deflected by ANAKIN's shields. ARTOO beeps.

ANAKIN: *(Cont'd)* This should stop them.

ANAKIN fires lasers as the ship begins to rotate.

ANAKIN: *(Cont'd)*...and take this!

He presses a button and launches two torpedoes which miss the DROIDS.

ANAKIN: *(Cont'd)* Darn...I missed!

The two torpedoes fly down a hallway and explode inside the reactor room.

ANAKIN: *(Cont'd)* Let's get out of here!

ANAKIN's ship roars through the hangar deck, bouncing over the DROIDS.

ANAKIN: *(Cont'd)* Now, this is Podracing! Whoopee!

INT. FEDERATION BATTLESHIP—BRIDGE

TEY HOW turns to CAPTAIN DOFINE.

TEY HOW: Sir, we're losing power... There is some problem with the main reactor...
DOFINE: Impossible!! I don't...

The bridge explodes.

INT. NABOO FIGHTER—COCKPIT—SPACE

RIC OLIÉ watches in amazement as the Federation battleship starts to explode from the inside out.

BRAVO TWO: What's that?? It's blowing up from the inside.

RIC OLIÉ: I don't know, we didn't hit it.

BRAVO THREE: Look! One of ours! Outta the main hold!!

EXT. NABOO GRASS PLAINS—DAY

Suddenly, all of the DROIDS begin to shake upside down, run around in circles, then stop. The GUNGANS carefully move out to inspect the FROZEN DROIDS. JAR JAR pushes one of the BATTLE DROIDS, and it falls over.

JAR JAR: Wierding...

EXT. THEED—CENTRAL HANGAR—DAY

ANAKIN and ARTOO follow the squad of yellow Naboo starfighters into the main hangar.

INT. THEED—CENTRAL HANGAR—DAY

RIC OLIÉ and the OTHER PILOTS gather around as they exit their ships.

BRAVO TWO: He flew into the hold, behind the deflector shield and blasted the main reactor...

BRAVO THREE: Amazing... They don't teach that at the academy.

ANAKIN'S ship skids to a stop behind the other Naboo starfighters. RIC OLIÉ, BRAVO TWO, the OTHER PILOTS, and GROUND CREW rush to his ship.

RIC OLIÉ: We're all accounted for. Who flew that ship?

ANAKIN sheepishly opens the cockpit and stands up. All the PILOTS stare in amazement.

ANAKIN: I'm not going to get in trouble, am I?

ARTOO beeps. Oh. Oh.

INT. MAIN HANGAR—COURTYARD—DAY

The large, grand cruiser of the Supreme Chancellor lands in the courtyard of the main hangar. CAPTAIN PANAKA and TWENTY TROOPS guard NUTE GUNRAY and RUNE HAAKO. OBI-WAN, the QUEEN, and her HANDMAIDENS stand before the NEIMOIDIANS.

PADMÉ: Now, Viceroy, you are going to have to go back to the Senate and explain all this.

CAPT. PANAKA: I think you can kiss your trade franchise good-bye.

The main ramp of the cruiser is lowered as OBI-WAN and CAPTAIN PANAKA lead the VICEROY and HIS ASSISTANT toward the ship. The GRAND CHANCELLOR PALPATINE and SEVERAL REPUBLIC GUARDS

descend the walkway, followed by YODA and SEVERAL OTHER JEDI MASTERS.

The CHANCELLOR PALPATINE is greeted by the QUEEN.

AMIDALA: Congratulations on your election, Chancellor. It is so good to see you again.

PALPATINE: It's good to be home. Your boldness has saved our people, Your Majesty. It is you who should be congratulated. Together we shall bring peace and prosperity to the Republic.

OBI-WAN greets YODA and the OTHER JEDI as CAPTAIN PANAKA takes the NEIMODIANS onto the cruiser.

INT. TURRET ROOM—NABOO PALACE—LATE DAY

The sun streams into the multi-windowed room at a low angle. It is not quite sunset. YODA paces before OBI-WAN, who is kneeling in the center of the room.

YODA: Confer on you, the level of Jedi Knight the Council does. But agree with your taking this boy as your Padawan learner, I do not.

OBI-WAN: Qui-Gon believed in him. I believe in Qui-Gon.

YODA: The Chosen One the boy may be; nevertheless, grave danger I fear in his training.

OBI-WAN: Master Yoda, I gave Qui-Gon my word. I *will* train Anakin. Without the approval of the Council if I must.

YODA: Qui-Gon's defiance I sense in you. Need that, you do not. Agree, the Council does. Your apprentice, young Skywalker will be.

EXT. THEED—CENTRAL PLAZA—FUNERAL TEMPLE STEPS—SUNSET

QUI-GON's body goes up in flames as the JEDI COUNCIL, the QUEEN, SIO BIBBLE, CAPTAIN PANAKA, the HANDMAIDENS, and ABOUT ONE HUNDRED NABOO TROOPS, TWENTY OTHER JEDI, PALPATINE, OBI-WAN (standing with ANAKIN), JAR JAR, BOSS NASS, and TWENTY OTHER GUNGAN WARRIORS watch. There is a drum roll that stops. Doves are released, and the body is gone. ANAKIN looks to OBI-WAN.

OBI-WAN: He is one with the Force, Anakin...You must let go.

ANAKIN: What will happen to me now?

OBI-WAN: I am your Master now. You will become a Jedi, I promise.

To one side, MACE WINDU turns to YODA.

MACE WINDU: There is no doubt. The mysterious warrior was a Sith.

YODA: Always two there are...no more...no less. A master and an apprentice.

MACE WINDU: But which one was destroyed, the master or the apprentice?

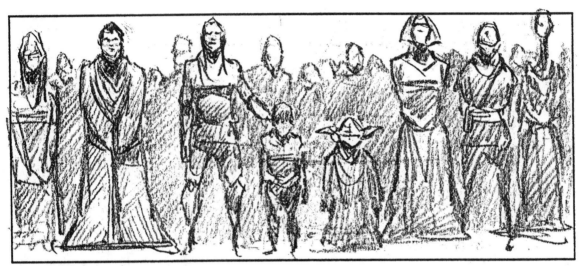

They give each other a concerned look.

EXT. THEED—CENTRAL PLAZA—DAY

*CHILDREN SING and throw flowers on the passing GUNGAN SOL-
DIERS. The CROWDS CHEER. It is a grand parade.*

 *QUEEN AMIDALA stands next to the SUPREME CHANCELLOR PAL-
PATINE, ANAKIN, OBI-WAN, SIO BIBBLE, and the JEDI COUNCIL.
ARTOO stands in front of the QUEEN'S HANDMAIDENS and whistles
at the parade. QUEEN AMIDALA and PALPATINE smile at one another.*

 *In the parade are BOSS NASS and his GUARDS, JAR JAR and GEN-
ERAL CEEL. The GUNGANS ride KAADU. They stop before the QUEEN
and walk up the steps to stand by her side. BOSS NASS holds up the
Globe of Peace. EVERYONE CHEERS. The parade marches on.*

IRIS OUT:
End titles

UNDERWATER
AND
SPACE BATTLE
STORYBOARD
SEQUENCES

What follows are storyboards that were

prepared for Episode I, early in the cre-

ative process. Though the story would

continue to evolve, these sequences

provided George Lucas with an invalu-

able tool as he directed the effort of

the actors and special effects artists.

UNDERWATER SEQUENCE

UW-015 part:A Duration:

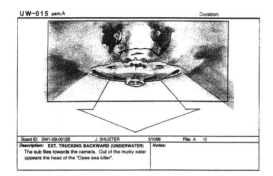

Board ID: SW1-SB-0012B J. SHUSTER 5/10/96 File: A 10
Description: EXT. TRUCKING BACKWARD (UNDERWATER) Notes:
The sub flies towards the camera. Out of the murky water
appears the head of the "Opee sea killer".

UW-015 part:B Duration:

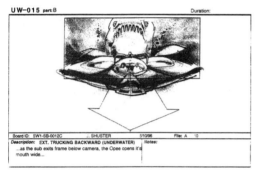

Board ID: SW1-SB-0012C J. SHUSTER 5/10/96 File: A 10
Description: EXT. TRUCKING BACKWARD (UNDERWATER) Notes:
...as the sub exits frame below camera, the Opee opens it's
mouth wide...

UW-015 part:C Duration:

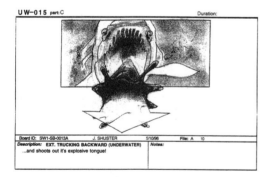

Board ID: SW1-SB-0013A J. SHUSTER 5/10/96 File: A 10
Description: EXT. TRUCKING BACKWARD (UNDERWATER) Notes:
...and shoots out it's explosive tongue!

UW-016 Duration:

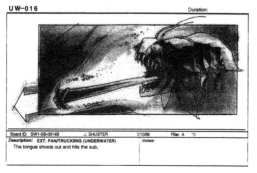

Board ID: SW1-SB-0014B J. SHUSTER 5/10/96 File: A 10
Description: EXT. PAN/TRUCKIING (UNDERWATER) Notes:
The tongue shoots out and hits the sub.

UW-017 Duration:

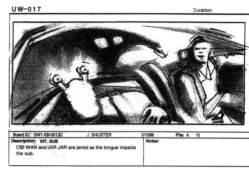

Board ID: SW1-SB-0013C J. SHUSTER 5/10/96 File: A 10
Description: INT. SUB Notes:
OBI WAN and JAR JAR are jarred as the tongue impacts
the sub.

UW-018 Duration:

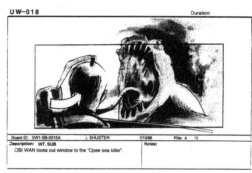

Board ID: SW1-SB-0015A J. SHUSTER 5/10/96 File: A 10
Description: INT. SUB Notes:
OBI WAN looks out window to the "Opee sea killer".

UW-019 Duration:

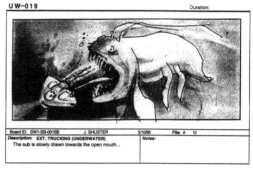

Board ID: SW1-SB-0015B J. SHUSTER 5/10/96 File: A 10
Description: EXT. TRUCKING (UNDERWATER) Notes:
The sub is slowly drawn towards the open mouth...

UW-020 Duration:

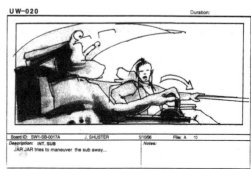

Board ID: SW1-SB-0017A J. SHUSTER 5/10/96 File: A 10
Description: INT. SUB Notes:
JAR JAR tries to maneuver the sub away...

UW-021 Duration:

Board ID: SW1-SB-0017B	J. SHUSTER	5/10/96	File: A 10

Description: EXT. TRUCKING (UNDERWATER) Notes:
The sub tries to pull away from the opee.

UW-025 Duration:

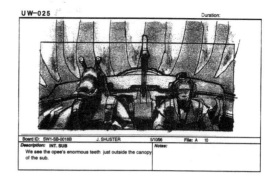

Board ID: SW1-SB-0018B	J. SHUSTER	5/10/96	File: A 10

Description: INT. SUB Notes:
We see the opee's enormous teeth just outside the canopy
of the sub.

UW-022 Duration:

Board ID: SW1-SB-0016A	J. SHUSTER	5/10/96	File: A 10

Description: INT. SUB ACROSS JAR JAR Notes:
JAR JAR is panic stricken as the sub is drawn into the
mouth.

UW-026 Duration:

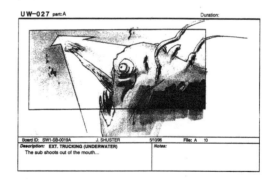

Board ID: SW1-SB-0017C	J. SHUSTER	5/10/96	File: A 10

Description: INT. SUB Notes:
OBI WAN yells "full speed ahead".

UW-023 Duration:

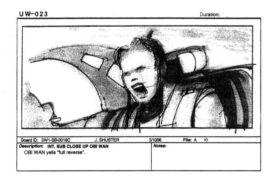

Board ID: SW1-SB-0018C	J. SHUSTER	5/10/96	File: A 10

Description: INT. SUB CLOSE UP OBI WAN Notes:
OBI WAN yells "full reverse".

UW-027 part: A Duration:

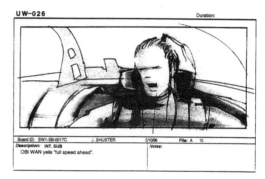

Board ID: SW1-SB-0019A	J. SHUSTER	5/10/96	File: A 10

Description: EXT. TRUCKING (UNDERWATER) Notes:
The sub shoots out of the mouth...

UW-024 Duration:

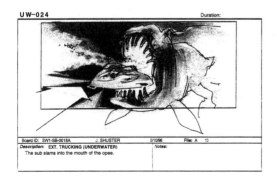

Board ID: SW1-SB-0018A	J. SHUSTER	5/10/96	File: A 10

Description: EXT. TRUCKING (UNDERWATER) Notes:
The sub slams into the mouth of the opee.

UW-027 part: B Duration:

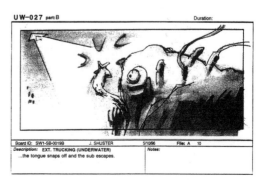

Board ID: SW1-SB-0019B	J. SHUSTER	5/10/96	File: A 10

Description: EXT. TRUCKING (UNDERWATER) Notes:
...the tongue snaps off and the sub escapes.

UW-028 Duration:

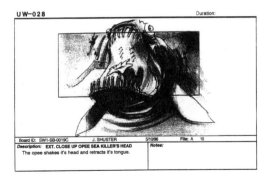

Board ID: SW1-SB-0019C J. SHUSTER 5/10/96 File: A 10
Description: **EXT. CLOSE UP OPEE SEA KILLER'S HEAD** *Notes:*
The opee shakes it's head and retracts it's tongue.

UW-029 Duration:

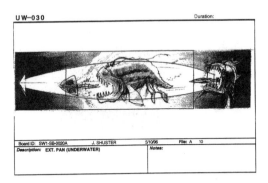

Board ID: SW1-SB-0021A J. SHUSTER 5/10/96 File: A 10
Description: **EXT. TRUCKING (UNDERWATER)** *Notes:*
The opee takes off in pursuit of the sub.

UW-030 Duration:

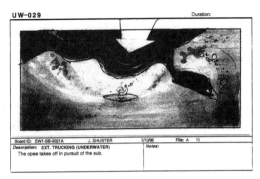

Board ID: SW1-SB-0020A J. SHUSTER 5/10/96 File: A 10
Description: **EXT. PAN (UNDERWATER)** *Notes:*

UW-031 Duration:

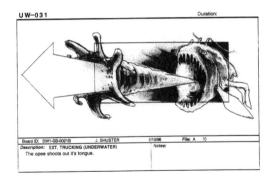

Board ID: SW1-SB-0021B J. SHUSTER 5/10/96 File: A 10
Description: **EXT. TRUCKING (UNDERWATER)** *Notes:*
The opee shoots out it's tongue.

UW-032 part:A Duration:

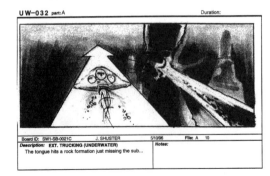

Board ID: SW1-SB-0021C J. SHUSTER 5/10/96 File: A 10
Description: **EXT. TRUCKING (UNDERWATER)** *Notes:*
The tongue hits a rock formation just missing the sub...

UW-032 part:B Duration:

Board ID: SW1-SB-0022A J. SHUSTER 5/10/96 File: A 10
Description: **EXT. TRUCKING (UNDERWATER)** *Notes:*
The rock formation explodes. The sub veers left.

UW-033 Duration:

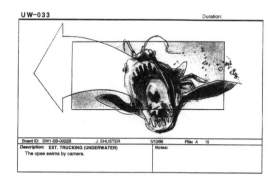

Board ID: SW1-SB-0022B J. SHUSTER 5/10/96 File: A 10
Description: **EXT. TRUCKING (UNDERWATER)** *Notes:*
The opee swims by camera.

UW-034 Duration:

Board ID: SW1-SB-0022C J. SHUSTER 5/10/96 File: A 10
Description: **EXT. TRUCKING (UNDERWATER)** *Notes:*
The sub veers right towards a canyon/tunnel.

SPACE BATTLE SEQUENCE

SB-003 Duration:

Board ID: SW1-SB-0600B	E. NATIVIDAD	11/26/96	File: D 10

Description: INT. STARFIGHTER COCKPIT
ANAKIN at the controls.

Notes:
037 in sequence

SB-004 Duration:

Board ID: SW1-SB-0603A	E. NATIVIDAD	11/26/96	File: D 10

Description: EXT. SPACE
Another Starfighter.

Notes:
037 in sequence

SB-005 Duration:

Board ID: SW1-SB-0601B	E. NATIVIDAD	11/26/96	File: D 10

Description: INT. OTHER STARFIGHTER COCKPIT
CU the other pilot.

Notes:
037 in sequence

SB-006 Duration:

Board ID: SW1-SB-0601C	E. NATIVIDAD	11/26/96	File: D 10

Description: EXT. SPACE
We follow the starfighters.

Notes:
037 in sequence

SB-008 Duration:

Board ID: SW1-SB-0603B	E. NATIVIDAD	11/26/96	File: D 10

Description: INT. STARFIGHTER
CU of the pilot.

Notes:
037 in sequence

SB-009 Duration:

Board ID: SW1-SB-0604A	E. NATIVIDAD	11/26/96	File: D 10

Description: EXT. SPACE
NABOO Starfighter POV.

Notes:
037 in sequence

SB-010 part:A Duration:

Board ID: SW1-SB-0602A	E. NATIVIDAD	11/26/96	File: D 10

Description: EXT. SPACE. TILT.
Camera tilts up from the advancing ships to...

Notes:
037 in sequence

SB-010 part:B Duration:

Board ID: SW1-SB-0604B	E. NATIVIDAD	11/26/96	File: D 10

Description: EXT. SPACE. TILT.
... the looming Star Destroyer.

Notes:
037 in sequence

SB-011 part:A Duration:

Board ID: SW1-SB-0602B	E. NATIVIDAD	11/26/96	File: D 10

Description: EXT. SPACE, PAN.
Hundreds of Federation Ships fly out of the destroyers.
Camera PANS to follow.

Notes:
037 in sequence

SB-011 part:B Duration:

Board ID: SW1-SB-0605A	E. NATIVIDAD	11/26/96	File: D 10

Description: EXT. SPACE, PAN.
Continues. We see the Naboo force in the distance.

Notes:
037 in sequence

SB-012 Duration:

Board ID: SW1-SB-0605B	E. NATIVIDAD	11/26/96	File: D 10

Description: EXT. SPACE
The Naboo Fighters zoom overhead.

Notes:
037 in sequence

SB-013 Duration:

Board ID: SW1-SB-0605C	E. NATIVIDAD	11/26/96	File: D 10

Description: EXT. SPACE
CU of ANAKIN.

Notes:
037 in sequence

SB-014 Duration:

Board ID: SW1-SB-0606A	E. NATIVIDAD	11/26/96	File: D 10

Description: INT. STARFIGHTER COCKPIT.
ANAKIN POV as several Fed. Fighters fly by.

Notes:
037 in sequence

SB-015 Duration:

Board ID: SW1-SB-0606B	E. NATIVIDAD	11/26/96	File: D 10

Description: EXT. SPACE
ANAKIN gives chase to one of the Fed. Ships.

Notes:
037 in sequence

SB-016 Duration:

Board ID: SW1-SB-0606C	E. NATIVIDAD	11/26/96	File: D 10

Description: EXT. SPACE
ANAKIN, however, flies too fast and passes the Fed. Ship.

Notes:
037 in sequence

SB-017 part:A Duration:

Board ID: SW1-SB-0607A	E. NATIVIDAD	11/26/96	File: D 10

Description: EXT. SPACE
ANAKIN swoops up...

Notes:
037 in sequence

SB-017 part: B Duration:

| Board ID: SW1-SB-0607B | E. NATIVIDAD | 11/26/96 | File: D 10 |
| Description: EXT. SPACE ...the Fed. Ship follows. | | Notes: 037 in sequence | |

SB-018 Duration:

| Board ID: SW1-SB-0600A | E. NATIVIDAD | 11/26/96 | File: D 10 |
| Description: INT. COCKPIT ANAKIN looks over his shoulder at the pursuing ship. | | Notes: 037 in sequence | |

SB-019 Duration:

| Board ID: SW1-SB-0614A | E. NATIVIDAD | 11/26/96 | File: D 10 |
| Description: INT. COCKPIT CU of the droid pilot taking aim. | | Notes: 037 in sequence | |

SB-020 part: A Duration:

| Board ID: SW1-SB-0614B | E. NATIVIDAD | 11/26/96 | File: D 10 |
| Description: EXT. SPACE The Fed. Ship fires. We follow the dogfight. | | Notes: 037 in sequence | |

SB-020 part: B Duration:

| Board ID: SW1-SB-0618B | E. NATIVIDAD | 11/26/96 | File: D 10 |
| Description: EXT. SPACE The 2 ships fly towards a destroyer. | | Notes: 037 in sequence | |

SB-020 part: C Duration:

| Board ID: SW1-SB-0618C | E. NATIVIDAD | 11/26/96 | File: D 10 |
| Description: EXT. SPACE Continue action as the Fed. Ship chases ANAKIN. | | Notes: 037 in sequence | |

SB-021 Duration:

| Board ID: SW1-SB-0608A | E. NATIVIDAD | 11/26/96 | File: D 10 |
| Description: EXT. SPACE. TILT. ANAKIN can't shake his pursuer as they skim the surface. Suddenly another Naboo Ship flies into frame. | | Notes: 037 in sequence | |

SB-022 part: A Duration:

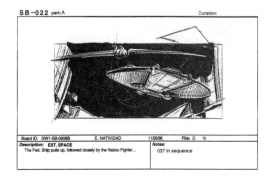

| Board ID: SW1-SB-0608B | E. NATIVIDAD | 11/26/96 | File: D 10 |
| Description: EXT. SPACE The Fed. Ship pulls up, followed closely by the Naboo Fighter... | | Notes: 037 in sequence | |

SB-022 part: B Duration:

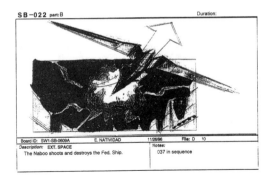

Board ID:	SW1-SB-0609A	E. NATIVIDAD	11/26/96	File: D	10

Description: EXT. SPACE
The Naboo shoots and destroys the Fed. Ship.

Notes:
037 in sequence

SB-023 Duration:

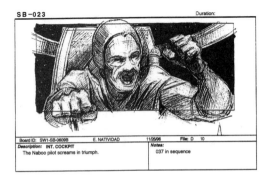

Board ID:	SW1-SB-0609B	E. NATIVIDAD	11/26/96	File: D	10

Description: INT. COCKPIT
The Naboo pilot screams in triumph.

Notes:
037 in sequence

SB-024 Duration:

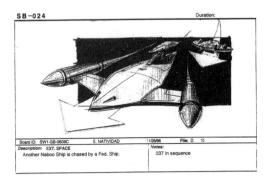

Board ID:	SW1-SB-0609C	E. NATIVIDAD	11/26/96	File: D	10

Description: EXT. SPACE
Another Naboo Ship is chased by a Fed. Ship.

Notes:
037 in sequence

SB-025 Duration:

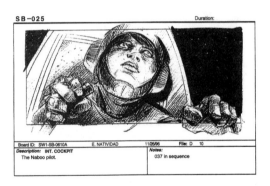

Board ID:	SW1-SB-0610A	E. NATIVIDAD	11/26/96	File: D	10

Description: INT. COCKPIT
The Naboo pilot.

Notes:
037 in sequence

SB-026 Duration:

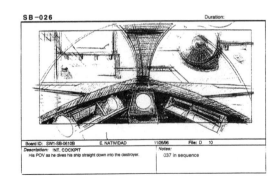

Board ID:	SW1-SB-0610B	E. NATIVIDAD	11/26/96	File: D	10

Description: INT. COCKPIT
His POV as he dives his ship straight down into the destroyer.

Notes:
037 in sequence

SB-027 part: A Duration:

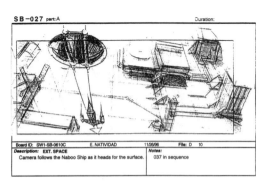

Board ID:	SW1-SB-0610C	E. NATIVIDAD	11/26/96	File: D	10

Description: EXT. SPACE
Camera follows the Naboo Ship as it heads for the surface.

Notes:
037 in sequence

SB-027 part: B Duration:

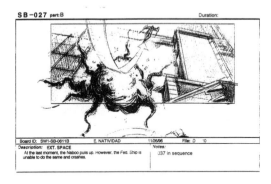

Board ID:	SW1-SB-0611B	E. NATIVIDAD	11/26/96	File: D	10

Description: EXT. SPACE
At the last moment, the Naboo pulls up. However, the Fed. Ship is unable to do the same and crashes.

Notes:
037 in sequence